The Campus History Series

UNIVERSITY OF

RICHMOND

ON THE COVER: Prof. Garnett Ryland leads the commencement procession in 1929 with Sarah Brunet Hall in the background. (Dementi Studio.)

The Campus History Series

UNIVERSITY OF

RICHMOND

JOHN REUBEN ALLEY
INTRODUCTION BY ROBERT S. ALLEY JR.

ARCADIA
PUBLISHING

Copyright © 2010 by John Reuben Alley
ISBN 978-0-7385-6660-3

Published by Arcadia Publishing
Charleston SC, Chicago IL, Portsmouth NH, San Francisco CA

Printed in the United States of America

Library of Congress Catalog Card Number: 2009931823

For all general information contact Arcadia Publishing at:
Telephone 843-853-2070
Fax 843-853-0044
E-mail sales@arcadiapublishing.com
For customer service and orders:
Toll-Free 1-888-313-2665

Visit us on the Internet at www.arcadiapublishing.com

This book is dedicated to our parents,
Robert S. Alley and Norma C. Alley,
who devoted their lives to the University of Richmond
and made it a home for our family.

CONTENTS

Acknowledgments 6

Introduction 7

1. The Seminary and Richmond College: 1830–1913 9

2. Spires and Gargoyles: 1914–1945 27

3. A Local University: 1946–1968 65

4. Five Schools, One University: 1969–2008 93

ACKNOWLEDGMENTS

This book would not have happened without the support and encouragement of Fred Anderson and Darlene Herod in the Virginia Baptist Historical Society. Carolyn Martin in the president's office was not only a good friend of my father, she also proved to be a friend in championing this project and spending time to provide honest feedback. In the communications department, I want to thank Mary Jane Mann for her many meetings with me to locate photographs in their collection. Karl Rhodes was an important resource with his knowledge of the University of Richmond's history. Andrew McBride, the university's architect, was generous with his time and shared the original architectural drawings for the school. I want to thank Shaun Aigner-Lee, the studio manager at the Dementi Studio, for her help in researching their important and impressive collection of images. I wish to thank also Meghan Holder at the Valentine Richmond History Center, Dana Angell Puga at the Library of Virginia, and the staff at the prints and photographs division of the Library of Congress. I want to thank my editor, Elizabeth Bray, for her expertise and unwavering support of this project. As a book inspired by family, I want to acknowledge my father-in-law, Ed Wray, and my mother-in-law, University of Richmond professor Elisabeth Wray, for our shared dedication to history and the University of Richmond. I want to acknowledge those who are also the grandsons of Reuben E. Alley. First, I have shared with my cousin Robert W. Alley fond memories of listening to my grandfather discussing family topics regarding the University of Richmond. Further, I'm proud to have worked on this book with my brother, Robert S. Alley Jr., remembering our years growing up on campus with our grandfather and parents. As always, I want to thank my wife, Vickie Alley, who I had the good fortune of meeting at the University of Richmond, for her trusted opinion and indefatigable support.

The images in this volume appear courtesy of the Virginia Baptist Historical Society, the Dementi Studio, the Library of Virginia, the Valentine Richmond History Center, the Library of Congress, the University of Richmond communications department, University of Richmond facilities department, the *Web* yearbook (*Web*), the *Collegian*, the University of Richmond athletics department, NASA, Doug Buerlein Photography, and Getty Images.

INTRODUCTION

It was 5:00 a.m. on June 8, 1830, and a large number of delegates to the eighth annual session of the Virginia Baptist General Association in Richmond were convening a meeting in the Second Baptist Church to discuss the formation of "an Education Society for the improvement of the ministry." The delegates resolved to create the Virginia Baptist Education Society and appointed a committee to devise a plan of action. Later that same day, the committee offered a plan and a constitution and recommended their immediate adoption. The larger group enthusiastically complied, and the University of Richmond was born. It would be another 90 years before the school would take that name and find a permanent home in its present location in the West End of Richmond.

Initially the school had 13 students and one teacher, the aptly named Edward Baptist. The students lived and studied in his home, Dunlora, in Powhatan County. In 1832, the newly named Virginia Baptist Seminary moved to 200 acres known as Spring Farm not far from where Bryan Park is today. Life was not easy for the 14 students who studied and worked under the direction of the Reverend Robert Ryland. The students had to work the farm several hours a day to pay for their tuition. Discipline was strict, and recreation was nonexistent. After two years, the school sold the farm in 1834 and moved to the Haxall estate in Richmond. It would remain at this site for the next 76 years. The move also marked the beginning of a relationship between the city and the school that has been immeasurably beneficial to both and has lasted for nearly two centuries. The history of Richmond has also been the history of the University of Richmond.

The Haxall estate, named Columbia, had been the home of Philip Haxall, who owned the Haxall Flour Mills and was one of the city's early giants of industry. The house and property, located at what is now the intersection of Grace and Lombardy Streets, were sold to the Virginia Baptist Education Society by Clara Walker Haxall in 1834. Her husband, Philip, had died in 1831.

In 1840, the Virginia Baptist Education Society decided to incorporate the school as a liberal arts college, and on March 4, it was chartered by the Virginia General Assembly as Richmond College. By 1860, the college had seen its average enrollment rise to about 120 and its endowment increase to $75,000, and Richmond had become arguably the most significant city in the South. The Civil War spelled disaster for both the city and the college. By the war's end in 1865, the former was reduced to ruins, and the latter was nothing more than a collection of looted buildings. In 1861, classes were suspended, the physical plant was turned over to the Confederacy for use as a hospital, and the entire endowment was invested in Confederate bonds. When Richmond fell in 1865, the school was used by the Union army as a barracks, and during this time, almost all the volumes that made up the library were lost.

As the city began to rebuild after the war, so did the college. In 1866, the school reorganized itself. Independent schools, or departments, were created, including one devoted to the study of English, perhaps the first such department in the United States. Robert Ryland resigned as president after 34 years and was replaced by Tiberius Gracchus Jones. However, by 1869, the school's financial difficulties had not improved, and the faculty pressed for reorganization. Thus began a 25-year period during which a faculty committee served as the administration of the school and the office of president ceased to exist. Over the next quarter century, Richmond College survived and even managed to grow with the addition of the T. C. Williams School of Law in 1889.

Crisis returned in 1893, though, in the form of a nationwide downturn in the economy. The board of trustees decided that leadership was needed in these hard times. On December 11, 1894, they chose 26-year-old Frederic W. Boatwright to be the school's new president. Boatwright began his duties as president in June 1895 with a faculty that resented him, an enrollment of 183, and a meager endowment. However, by 1898, women were accepted as students for the first time, a new science building had been built and paid for, and a new dormitory was near completion. This was the beginning of a remarkable career as president that would last for 51 years.

When Boatwright retired in 1946, the college in crisis had grown to be one of the most prestigious colleges in the nation. Meanwhile, Richmond had risen from the ruins of the Civil War to become a thriving city again. Reflecting the westward growth of the city, Boatwright oversaw the moving of the campus to the current site in the area known as Westhampton. In 1914, Richmond College and Westhampton College, the newly founded school for women, opened on 300 acres surrounding a lake that had been used as an amusement park west of the city. In 1920, the charter was changed, and the two colleges became collectively known as the University of Richmond.

In the 51 years following Boatwright's death in 1951, the University of Richmond continued to thrive and grow under the leadership of five presidents, George Modlin (1946–1971), E. Bruce Heilman (1971–1986), Samuel Banks (1986–1987), Richard Morrill (1988–1998), and William E. Cooper (1998–2007). During those years, the Boatwright Memorial Library was dedicated in 1955; University College, which later became the School of Continuing Studies, opened in 1962; the first black students attended classes in 1964; and the Spiders football team defeated Ohio in the Tangerine Bowl in 1968. In 1969, E. Claiborne Robins donated $50 million to the University of Richmond, which was, at the time, the largest cash gift ever given to an American university by a living donor. The Robins Center opened its doors for the first time in 1972, and a new student commons spanning the lake and connecting the two campuses was completed in 1976. A year later, the Gottwald Science Center opened, and in 1992, the Jepson School of Leadership was dedicated. Fittingly, the university also hosted a presidential debate in 1992 between Pres. George H. W. Bush, Bill Clinton, and Ross Perot.

In 2007, Edward L. Ayers became the ninth president of the University of Richmond. Dr. Ayers is a leading scholar on the history of the American South and recognizes the significance of the university in the history of the city, the state, and the region. Under his leadership, the University of Richmond Downtown program began. Bringing the school back to its roots, this program enables all parts and programs of the University of Richmond to connect with the city of Richmond. It features public lectures, undergraduate and law classes, clinical and pro bono legal services, community-based research, community events and meetings, and a small public gallery. Recently Dr. Ayers and the University of Richmond hosted a forum entitled "The Future of Richmond's Past" to discuss how best to tell the story of Richmond for the dual sesquicentennial of the Civil War and the end of slavery. Through activities and programs such as these, the University of Richmond continues to maintain and nourish a partnership with the city that began 175 years ago in a mansion at the end of Grace Street.

—Robert S. Alley Jr.

One

THE SEMINARY AND RICHMOND COLLEGE
1830–1913

Virginia Baptists were the founders of the school that today is the University of Richmond. As defenders of religious freedom, they recognized the necessary role of education in their faith and in the community. Specifically, Virginia Baptists supported education and the pursuit of knowledge for young men training to be ministers. In 1830, Rev. Edward Baptist took this charge as he began teaching ministerial students at Dunlora, a plantation in Powhatan. From those early efforts, the Virginia Baptist Seminary was founded in 1832 under the leadership of Rev. Robert Ryland at Spring Farm, a rural site north of Richmond. In 1834, the school moved to the city, purchasing the Haxall mansion known as Columbia on Lombardy Street.

Extolling the pursuit of knowledge through reason and the exploration of science, the Virginia Baptists' appreciation for classical scholarship can be seen in the development of the seminary to a liberal arts college. This occurred in 1840, when the school was officially incorporated by the Virginia legislature as Richmond College, which welcomed both ministerial and "literary" students. The ideals of the school were expressed in the Richmond College seal, introduced in 1840, *Verbum Vitae et Lumen Scientiae*, or "The Life of the Word and The Light of Science."

Involved with the issues of the day, Virginia Baptists had taken a formal stance against slavery in 1790. In spite of that, through the years, local Southern attitudes regarding the "peculiar institution" and segregation would often prevail. However, similar to the Constitution and the nation's founding fathers at large, the ideals of education and intellectual freedom would have the power to transcend human failings and allow the institution to continually renew itself with each generation.

During the later part of the 19th century, the school enjoyed enthusiastic support as a city college. Athletics became a draw to the local community, and it was during that time the school acquired its unusual Spider mascot. Robert Ryland was a seminal figure, as the first president from 1841 to 1866. Following the Civil War, Pres. Tiberius Gracchus Jones served from 1866 to 1869. The school then operated under faculty leadership for 26 years. A change to that structure occurred in 1894, as the faculty-run system came to an end and 26-year-old Prof. Frederic Boatwright became president of Richmond College. In this position, Boatwright would set the direction of the Richmond College and the University of Richmond for the next 51 years.

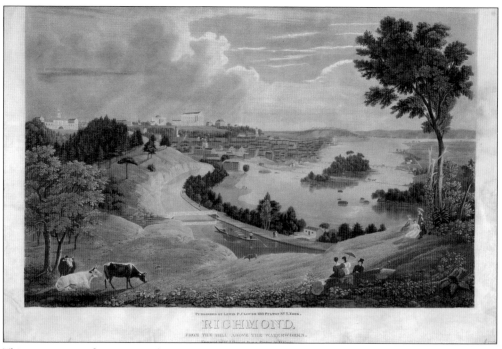

This engraving of a painting by George Cooke depicts the city of Richmond during the time that the story of the University of Richmond begins, in 1830—a time when engravings were a popular medium, prior to the appearance of photography in 1839. This view overlooking the Kanawha Canal and the James River would have been familiar to the Virginia Baptists who envisioned a school to educate preachers in 1830. It was also the year that James Madison and other prominent Virginians gathered in Richmond for the Constitutional Convention of 1830. (Library of Congress.)

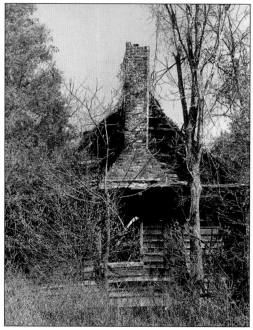

The school that would become the Virginia Baptist Seminary in 1832 began with instruction led by Edward Baptist at Dunlora. The remains of that structure are pictured here in Powhatan County. In 1948, the Commonwealth of Virginia department of historic resources erected a historical marker for Dunlora Academy. Following Dunlora, the Virginia Baptist Seminary was established at Spring Farm and was led by prominent Baptist Robert Ryland as the principal. He developed a curriculum that included manual labor—with students rising at the break of dawn followed by prayer and instruction. (Virginia Baptist Historical Society.)

In 1834, Spring Farm closed, and the Virginia Baptist Education Society purchased the Haxall mansion on Lombardy Street in Richmond from Clara Walker Haxall, the widow of Phillip Haxall. Known as Columbia, the mansion was named for the Haxall family's successful Columbia flour mill in the city. Incorporated in 1840, Richmond College became a liberal arts institution on this site, and the campus became an important landmark in the city until its move to the West End in 1914. (Virginia Baptist Historical Society.)

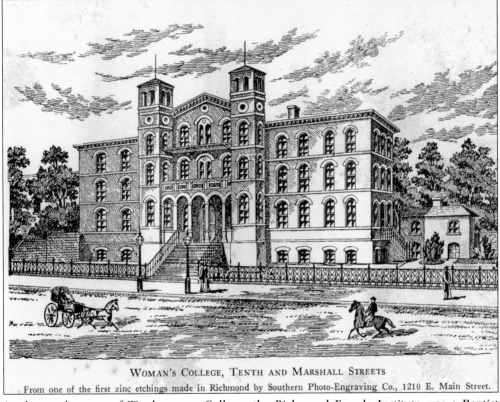

WOMAN'S COLLEGE, TENTH AND MARSHALL STREETS
From one of the first zinc etchings made in Richmond by Southern Photo-Engraving Co., 1210 E. Main Street.

As the predecessor of Westhampton College, the Richmond Female Institute was a Baptist institution, sharing trustees with Richmond College. Located at Tenth and Marshall Streets, the school was transformed into the Woman's College of Richmond in 1894 and officially suspended operation in 1916. President Boatwright admitted four women to Richmond College in 1898—a number that would grow to approximately 30 in 1910, just prior to the founding of Westhampton College. (Virginia Baptist Historical Society.)

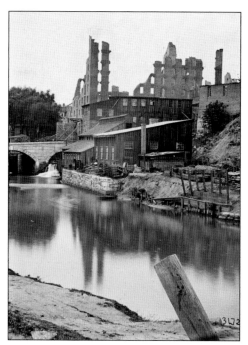

The fall of Richmond, which brought the Civil War to an end devastated Richmond College as well. Closed during the war, the college served as a hospital and quarters for Union troops after the burning of Richmond. This 1865 glass-plate image was taken near the Haxall Flour Mills after the fire with Gallego Mills visible across the Kanawha Canal. In retrospect, Pres. Robert Ryland stated as mistakes two decisions he made during his administration leading up to the Civil War. He regretted installing gaslights on campus and building the school's endowment on Confederate bonds, an act of loyalty to the Southern cause that threatened to close the school permanently after the war. Financial ruin was narrowly averted through the contributions of Richmond businessman James Thomas. His support was recognized in the naming of the Thomas Museum and Art Gallery and Thomas Hall. (Library of Congress.)

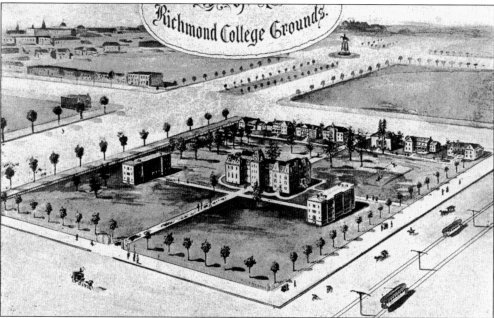

Depicting the Robert E. Lee Monument to the west, this drawing shows the campus bordered by Franklin Street (to the south), Lombardy Street (to the west), Broad Street (to the north), and Ryland Street (to the east). The campus was a significant landmark. The path to the main center building on Ryland would become an extension of Grace Street following the college's move to the western suburbs in 1914. After that move, the campus was razed, with the exception of the Columbia mansion. Memorial columns that stand today were erected to indicate the location of the campus at the corners of Lombardy and Grace Street to the west and Ryland and Grace Streets to the east. (Virginia Baptist Historical Society.)

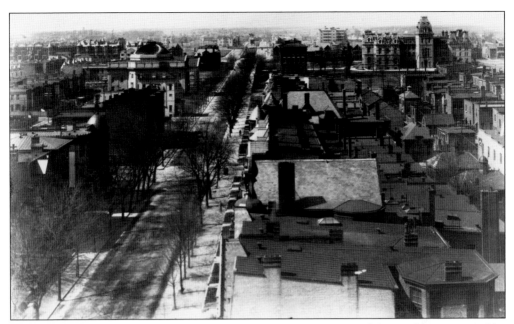

This photograph of the campus from the east provides a glimpse of the rooflines accented by the main building of the Richmond College campus. Among the early alumni who knew this building as their alma mater were Pulitzer Prize–winning author Douglas Southall Freeman, along with popular local newspaper columnists Edwin Yoder and Evan Ragland Chesterman. (Virginia Baptist Historical Society.)

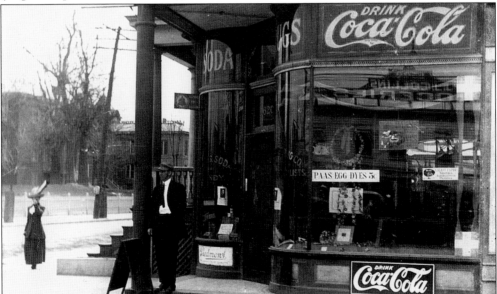

The L. T. Wright Drug Store appears here around 1890 at the corner of Lombardy and Broad Streets. From this view, the fence and faculty residences on the Richmond College campus can be seen faintly to the left on Lombardy. This provides a glimpse of the Broad Street neighborhood surrounding the school around the beginning of the 20th century. This drugstore would have certainly been familiar to faculty and students, who could have relaxed to drink Coca-Cola, which had recently been introduced in the late 19th century. (Library of Virginia.)

13

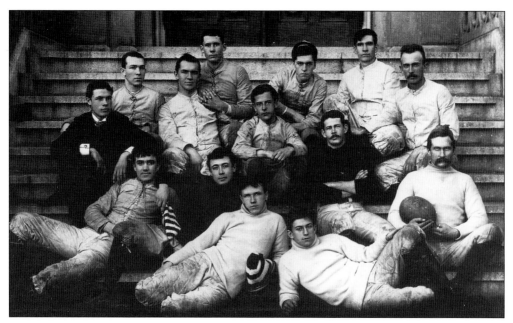

The 1892 football team is pictured here on the steps of Jeter Hall. Richmond football won its first game against Randolph Macon College in 1881. Early on, the team was referred to in the local newspaper as the Mules and Puryear's Colts in reference to Bennett Puryear, a professor of chemistry and chairman of the faculty under the school's faculty leadership prior to Frederic Boatwright becoming president of Richmond College in 1894. (Library of Virginia.)

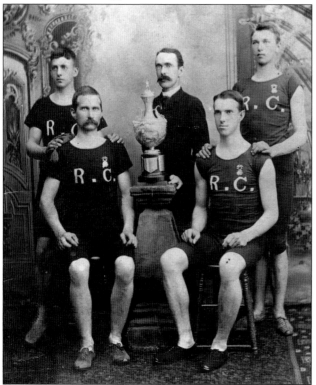

An image of the Richmond College basketball team on the old campus, this was the beginning of a tradition that continued to the new campus—to Mac Pitt taking his first team to the only undefeated record (20-0) in Spider history and then to the thrilling career of coach Dick Tarrant, some 100 years after this photograph was taken. (*Web.*)

This notice for Richmond College in 1909 provides a glimpse of what the college offered during that period. As a historical account of that time, alumnus John Cutchins describes the experience of a new student arriving to town on the streetcar in his book *History of the Class of 1905*. "As the newcomer boarded the car, and stowed his baggage with the help of the conductor, he had the opportunity to look around him at the large buildings, some as much as three, and occasionally even four, stories high (!), and to note the activity (if it might be called such) of the big city . . . he saw happy children playing in complete safety on the streets, gathered around the organ grinder with his hurdy-gurdy, and the little monkey with the red cap." (*Web*.)

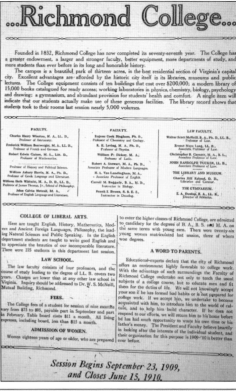

Cycling was wildly popular with students and Americans in general at the end of the 19th century. The *New York Times* ran stories of the great demand nationally for the new, modern safety bicycle appearing in 1885. It brought cycling as popular transportation to the masses as the Kodak Brownie did with photography. The advertisement above for "wheels" appeared in the 1900 Richmond College yearbook, which was entitled the *Spider*. (*Spider*.)

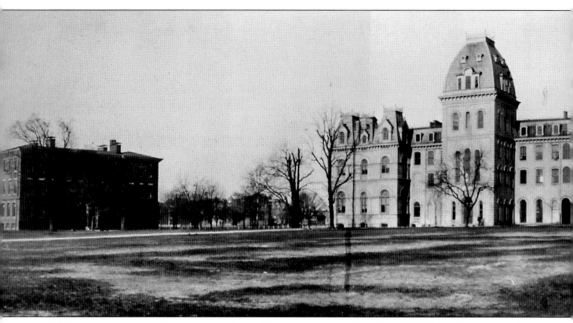

This panorama provides a clear view of the campus, with Ryland Hall in the center. From accounts of students familiar with the campus, the center building provided space for the chapel and meeting rooms, including rooms for fraternities. The path to the door would become what is present-day Grace Street upon the eventual demolition of campus buildings and grounds. The left side of the building included the Jeter Memorial Library and the Thomas Museum and

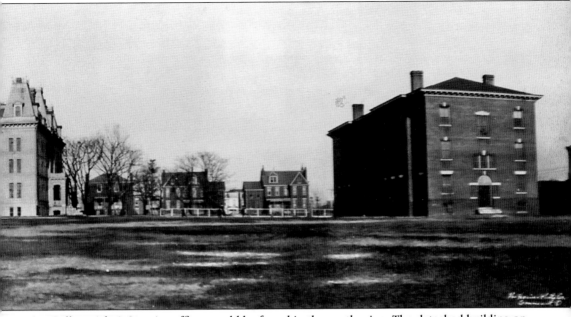

Art Gallery. Administrative offices could be found in the north wing. The detached building on the left facing Franklin Street was the Science Hall. Memorial Hall, seen to the right and facing Broad Street, served as student housing. To the west behind the main buildings on Lombardy Street were a row of houses for the president and faculty, including the Columbia mansion, which was the original building bought from the Haxall family in 1834. (Library of Congress.)

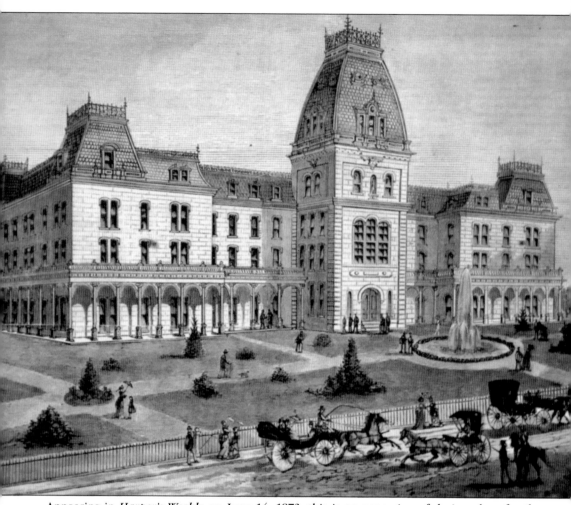

Appearing in *Harper's Weekly* on June 14, 1873, this is an engraving of design plans for the new Richmond College main building, which would significantly enlarge the visual presence of the campus in the city. The Columbia mansion had been the main building up to this point. The carriages pictured here represent local traffic on Ryland Street, running to the north to Broad Street and to Franklin Street to the south. In an accompanying article, *Harper's Weekly* reports that "the Baptist denomination in Virginia have done a noble work in establishing a well-endowed college at Richmond, in that state," predicting that the building "will be one of the most prominent architectural features of Richmond." The article continues to report that the building will be at the "head of Grace Street," with the features to include "commodious recitation rooms, library and museum, society halls, chapel, and dormitories." The endowment for Richmond College at the time was reported as being $300,000. (*Harper's Weekly.*)

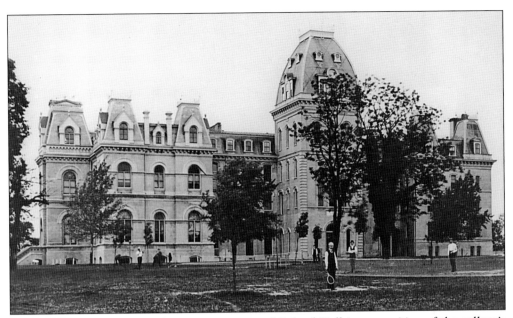

The main building of the old campus was named Ryland Hall in recognition of the college's first president. Positioned at the western end of Grace Street, the building burned in 1910, shortly before the college's move to the new campus, where Ryland Hall would again be one of the original and main buildings of the school. Tennis courts, pictured here, were a prominent feature on the campus grounds. (Virginia Baptist Historical Society.)

Tennis was a popular sport on the old campus. Grass tennis courts were central to the downtown campus. With the move to the new campus, tennis, archery, and field hockey were all strong athletic activities pursued by the men of Richmond College and Westhampton College women. (The Valentine Richmond History Center.)

19

The photograph below of the 1898 Richmond College baseball team was taken only a few years after the team acquired their peculiar mascot. The origin of the spider mascot has been traced to the 1894 baseball season and to reporter Evan Ragland Chesterman, who reported on the lanky pitcher Puss Ellyson. Ellyson seemed to take to the field with his fellow teammates as spiders in a web. Thinking about the symbolism of the odd mascot, an article in the *Collegian* dated February 13, 1920, suggested that the spider was "the synonym of success, good judgment and painstaking perseverance." The University of Richmond remains unique in having a spider as a mascot. However, a major-league baseball team, the Cleveland Spiders, shared the arachnid mascot from 1887 to 1899. (Both, Virginia Baptist Historical Society.)

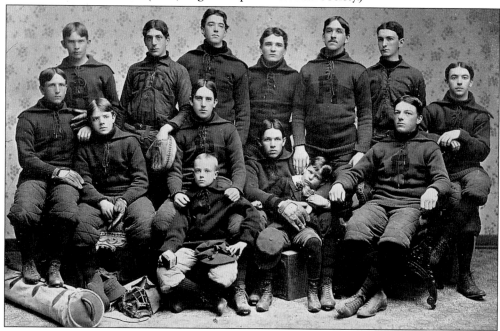

The Law School of Richmond College began instruction in 1870. Classes had to be suspended twice for financial reasons in the early years made worse by a depression nationally initiated by the Panic of 1873. The year 1890 is significant in that the school received $25,000 from the family of the recently deceased T. C. Williams, a successful tobacco merchant who had expressed a desire to secure the financial stability of the Law School. The endowment would establish the T. C. Williams Professorship of Law, which made it possible to continue instruction without suspension from that point forward. (Virginia Baptist Historical Society.)

The *Spider* yearbook published an illustration of the "toe pulling" tradition. Another venerable school publication, the *Messenger* in1897 recounted campus antics such as "the traditional practices of toe pulling, ringing the College bell at midnight, or . . . putting a goat or goose in the lecture-room." The author also pointed out how "the sobriquet of 'Lunatics' was fastened on the students of the College." (*Spider.*)

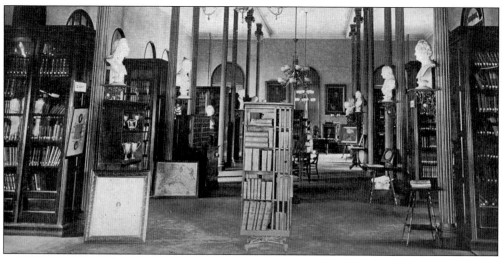

This was the library for Richmond College, located in Jeter Memorial Hall, the south wing of the main building, which was completed in 1884. Jeremiah Bell Jeter, who died in 1880, was an active Baptist leader and president of the board of trustees. The Jeter Memorial Hall Library opened with a collection of 10,000 volumes. Charles Ryland, nephew of Pres. Robert Ryland, was appointed during the 1883–1884 session as treasurer of the college, librarian, and curator of the Thomas Museum and Art Hall. He held these positions until his death in 1914. The space for the library in Ryland Hall on the new campus was named in his honor. Prior to that move, in 1905, the library had 15,000 volumes, as reported by President Boatwright. In this report, the president also identified the need for additional space, an issue that would not be fully addressed until the building of the Boatwright Memorial Library in 1955. (*Web.*)

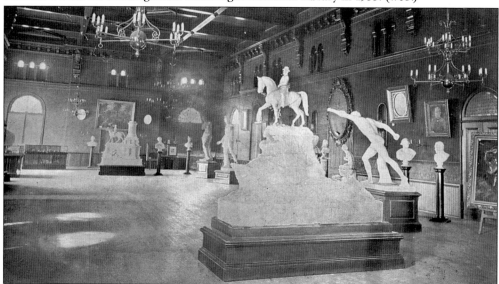

This photograph is one of the few visual records of the Thomas Museum and Art Hall. A *New York Times* article on April 17, 1881, announced the contribution of an ancient Chinese coin collection by Dr. R. H. Graves to the museum of Richmond College. Also, an Egyptian mummy donated by Richmond trustee and professor Jabez Lamar Monroe Curry was saved from the original collection, and currently the University of Richmond's Department of Classical Studies has it on display in its Ancient World Gallery in North Court. (*Web.*)

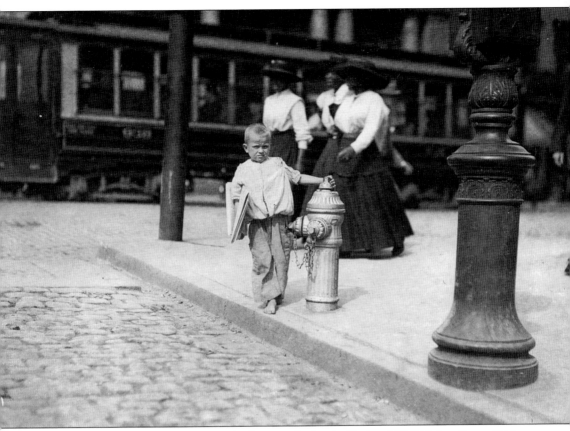

Early in the 20th century, Lewis Hine took photographs for the National Child Labor Committee, documenting working conditions of children that ultimately brought about reform. Hine visited Richmond in 1911 and photographed newsboys on the streets of Richmond, giving a view of Richmond's downtown, including the Richmond streetcar. Richmond was among the first cities in the nation to employ streetcars as a means of urban transportation. It was also the first in the nation to test a citywide system. (Library of Congress.)

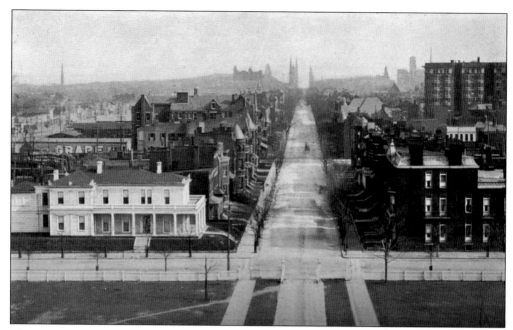

The campus was positioned at the end of Grace Street, between Broad, Franklin, Lombardy, and Ryland Streets. This photograph provides a view from the campus looking east down Grace Street. (Virginia Baptist Historical Society.)

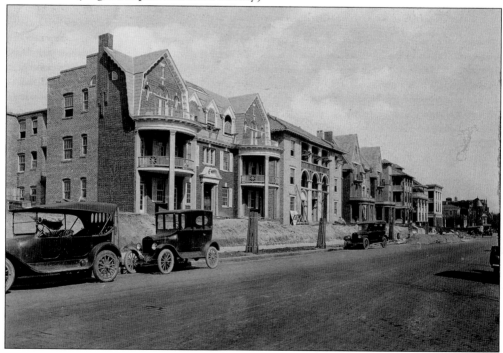

This 1922 image of housing developments on Grace Street shows what quickly replaced the demolished main buildings of the campus, allowing for the extension of Grace Street to the west through the land of the former campus. Prior to this, the entrance to the main building on Ryland Street interrupted Grace Street heading west. (The Valentine Richmond History Center.)

The student caricature pictured here in front of the main building represents traditions at the downtown campus, which operated for 80 years. Having started the job at age 26, President Boatwright would take these memories and traditions to the new campus. As a symbol, bricks from the old campus were laid to form the walkway in front of the new Ryland Hall. A fire in 1910 hastened the need for the new campus. It was speculated that the cause of the fire may have originated in the fraternity rooms or from a firecracker in the hall. Boatwright defended the students' honor and charges that liquor might have played a part, saying that such behavior would have been "contrary to explicit pledges they gave to me." (*Web.*)

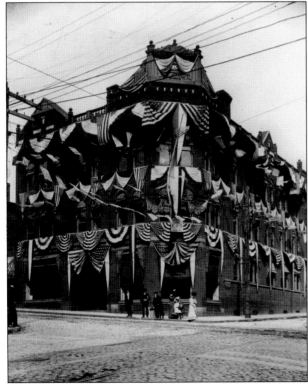

U.S. president Theodore Roosevelt visited Richmond on October 18, 1905. In his speech at Capitol Square, he declared, "I can not sufficiently express to you my deep appreciation of the way in which you have greeted me here to-day," responding to festive displays like the one seen here on the Virginia Passenger and Power Company building downtown. Roosevelt spoke at length on the effects of the Civil War that had ended only 40 years earlier—a war fought by fathers of Richmond College students, including the father of historian Douglas Southall Freeman, Richmond class of 1904. (Library of Virginia.)

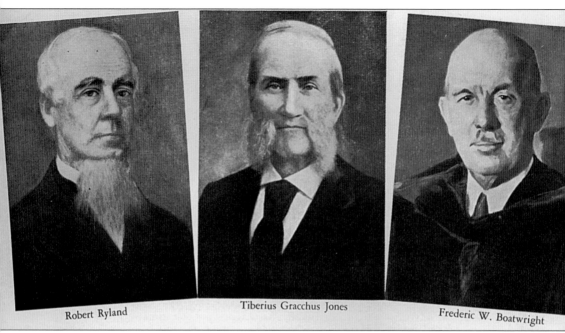

Robert Ryland

Tiberius Gracchus Jones

Frederic W. Boatwright

Robert Ryland (left) was the first president of the seminary and Richmond College prior to the Civil War. Tiberius Gracchus Jones (center) took the leadership role briefly, resigning and leaving the faculty to run the college for 26 years. While not a president, Bennett Puryear was the chairman of the faculty and was identified as a leader of the college for the majority of those years. The tenure of Frederic Boatwright (right) began in 1894. His 51 years as president would define Richmond College, Westhampton College, and the University of Richmond. (*Web.*)

Two

SPIRES AND GARGOYLES
1914–1945

The story of the school continues with President Boatwright's interest in moving the campus west. The development of the electric streetcar at the end of the 19th century played an important role in this move. The City of Richmond, with its range of hills and valleys connecting neighborhoods, was seen in 1888 as a good place to test the nation's first citywide streetcar system. With the various lines in place, streetcar companies encouraged ridership by building amusement parks at the ends of the routes. The Westham Amusement Corporation built such a park in the West End. As the glory days of the amusement park eventually declined, Boatwright saw Westham as a good site for the new campus. Beyond the need for more space, Boatwright had a vision of a school based on the model of Oxford University, wherein various colleges would be developed independently under one central administration. As a leader in education for women, Boatwright planned for the founding of Westhampton College as an important part of this vision and a rationale for the move west. In 1914, the spacious acres of the new campus would become the home for a new school structure, with a coordinate system between Westhampton College and Richmond College.

In 1910, Richmond College Trustees selected renowned architect Ralph Adams Cram and noted landscape designer Charles Gillette to design the new campus. As a proponent of Collegiate Gothic architecture, Cram designed buildings that promoted the feeling of a cloistered scholarly community—an environment he had created at Princeton University and the U.S. Military Academy at West Point. In his novel *This Side of Paradise*, F. Scott Fitzgerald describes the awe his main character feels among the "spires and gargoyles" of the Collegiate Gothic buildings at Princeton. To feel part of something larger than themselves, Cram hoped to provide the students, through the permanence of the Gothic structures, a sense of enduring values that would define their educational experience. The craftsmanship and art emerging from the mortar and limestone provided a visual manifestation of the ideals of truth and knowledge associated with scholarship.

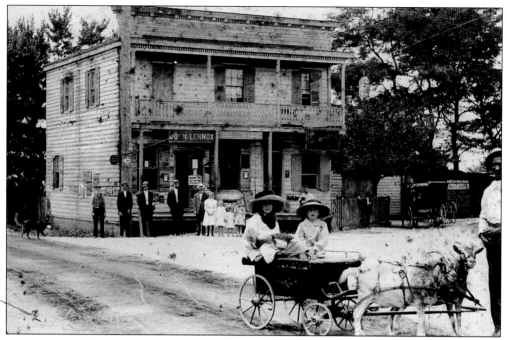

Lennox store (above) stood near the new campus at the intersection of Three Chopt Road and River Road at the current site of the Country Club of Virginia. In the book *The Trail of the Three Notch Road*, written in 1929, Richmond native Ethel Kelley Kern provides a narrative tour of Three Chopt, which starts at this intersection. "We now reached a very important spot; the parting of the ways." Kern moves north on Three Chopt Road to reach Towana Road and the entrance to the "university grounds." She continues to the house known as Huntley, which was owned by Ben Green in 1864, at the time of the Dahlgren Raid during the Civil War. That house still stands near the entrance to the University of Richmond at Boatwright Drive. (The Valentine Richmond History Center.)

With common interests in the neighborhood, the Westham Corporation maintained a relationship with the University of Richmond and President Boatwright. The Westham Corporation and Boatwright developed land that had been in the 19th-century village of Westham, which included the farm of Ben Green. His house, Huntley, at 6510 Three Chopt Road, was a part of a farm that extended to the current Westhampton Lake, which was a millpond. The land was also the site of some action in the Civil War, as Union colonel Ulric Dahlgren met resistance in this area. Colonel Dahlgren was reportedly attempting to find the river, invade the city, and assassinate Confederate president Jefferson Davis. After the Civil War, African Americans settled in this area near Bandy Field, off Three Chopt Road, and in Zion Town to the west of the current Westhampton campus. While taking a tour of the property of the failed amusement park in 1910, Boatwright and others noted African American residences on the hill near the lake. (Reuben E. Alley collection.)

This advertisement for Westhampton heralds the transportation benefits of the developing suburb, as it was connected to the city by the streetcar. Unfortunately for Westhampton women, attempts by the Westham Corporation in appealing to the Virginia Railway and Power Company to extend the streetcar along College Road to the entrance of the women's college failed. Therefore, a horse-and-carriage service was established to take the women to the other side of the lake. (The *Collegian*.)

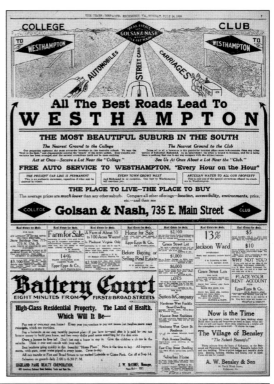

This view of College Road looking southeast from the perspective of the creek running to the lake (below present-day Pitt Field) shows the neighborhood at the time of the school's move to Westham. Baptist minister Rev. George W. McDaniel built the house to the left on the hill overlooking the lake. Clearly enthusiastic about Westham's potential as a residential development adjacent to the college, McDaniel was the minister of the First Baptist Church, a powerful influence in Baptist circles, and a member of the school's building committee. (The Valentine Richmond History Center.)

The Kodak girl was a familiar symbol of the camera craze associated with the introduction of the Brownie camera in 1900. Americans enjoyed leisure activities associated with snapping picturesque views with the Brownie in locations such as the Westhampton Park, pictured below. On the new campus, the pastime would continue, as Richmond and Westhampton College students could pick up camera supplies at the S. Galeski Optical Company on Broad Street, which advertised in the yearbook as the students' "Kodak headquarters." (Library of Congress.)

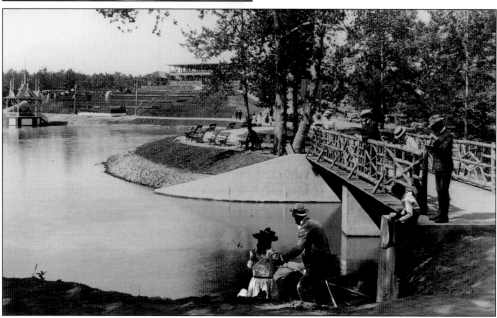

Westhampton Park was built at the terminus of the streetcar line. Westhampton Park Casino can be seen in the distance, on the hill where Boatwright Memorial Library now stands. On campus, this building came to be known as the Playhouse. The building had various uses, including an auditorium, chapel, and theater for the University Players. As the oldest building not designed by Ralph Cram still standing on the original site, the Playhouse was finally demolished in 1953 to make room for the Frederic W. Boatwright Memorial Library. (Dementi Studio.)

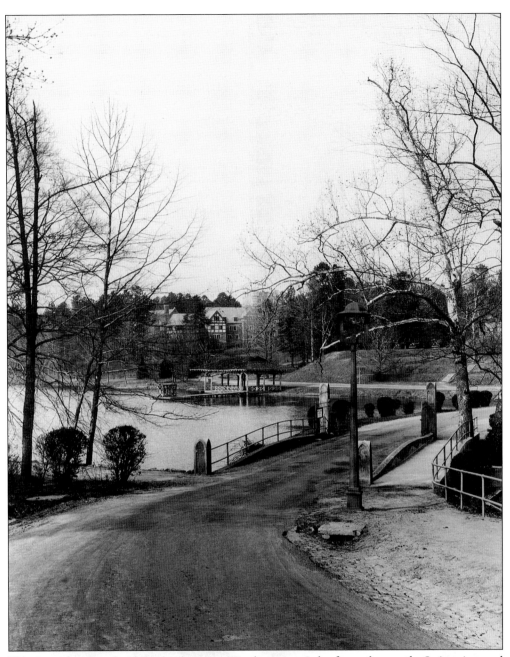

This is a photograph of the bridge over Westhampton Lake from the south. Swimming and fishing in the lake would be concerns over the years. In a letter to the Richmond College Student Government Association, President Boatwright rejects a request to allow unsupervised swimming and boating on the lake on Sundays. "The objection of boating on the lake on Sundays arises chiefly from the fear we have of accidents occurring when few students and no guards are in the vicinity of the lake." (Dementi Studio.)

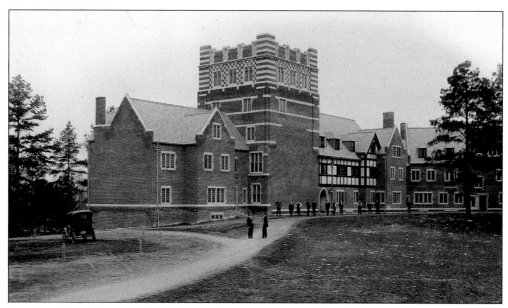

Designated initially as simply Dormitory No. 1, in 1915, this dormitory was named James Thomas Jr. Memorial Hall. Dormitory No. 2, named Jeter Hall, was a memorial to the trustee and Baptist leader Jeremiah Jeter. A successful businessman in Richmond, Thomas was a benefactor to the school. It was his $5,000 donation to the school that, by all accounts, prevented the school from closing permanently because of the school's investment in Confederate bonds. (Library of Virginia.)

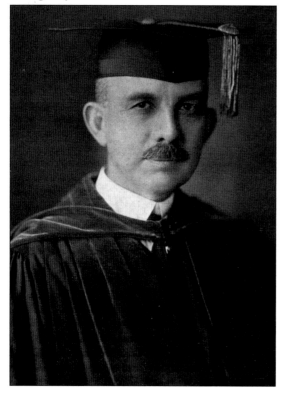

Frederic Boatwright worked closely with architect Ralph Cram and his firm of Cram, Goodhue, and Fergusson on the planning of the new campus in the Collegiate Gothic style. The Gothic approach was fitting, as Boatwright saw the school as developing according to the "English university plan with a group of separate inter-dependent coordinate colleges and with central university facilities," as he states in a letter to Cram. In addition to Westhampton and Richmond Colleges, Boatwright had plans for various schools, including a College of Practical Arts, a College of Fine Arts, a College of Commerce, and a College of Technology. (University of Richmond, communications department.)

Later appearing on the cover of *Time* magazine in 1926, Ralph Cram was recognized as a leading proponent of Collegiate Gothic architecture. A follower of John Ruskin's philosophy on the Gothic, Cram believed the ideal college experience to be one where students are surrounded by art in the material form of Gothic architecture, as he states, "not for the embellishment of the specialist but for all." (Library of Congress.)

Oxford University was the embodiment of the English plan for a campus, with multiple colleges as components of one university. Following this model, the Law School, Westhampton College, and Richmond College together became in 1920 the University of Richmond. Currently the University of Richmond includes five schools: the School of Arts and Sciences, the Jepson School of Leadership Studies, the School of Law, the E. Claiborne Robins School of Business, and the School of Continuing Studies. (Library of Congress.)

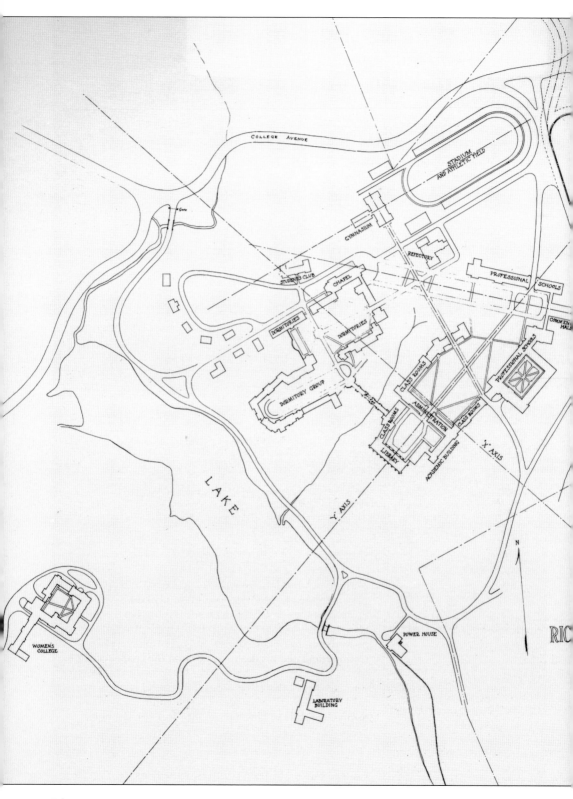

COLLEGE AVENUE

STADIUM
AND ATHLETIC FIELD

Gate

GYMNASIUM

REFECTORY

PROFESSIONAL SCHOOLS

STUDENTS CLUB

CHAPEL

COMMENS HALL

DORMITORIES

DORMITORIES

CLASS ROOMS

PROFESSIONAL SCHOOLS

DORMITORY GROUP

CLASS ROOMS

ADMINISTRATION

CLASS ROOMS

'X' AXIS

LIBRARY

ACADEMIC BUILDING

LAKE

Y AXIS

N

WOMENS
COLLEGE

POWER HOUSE

RIC

LABORATORY
BUILDING

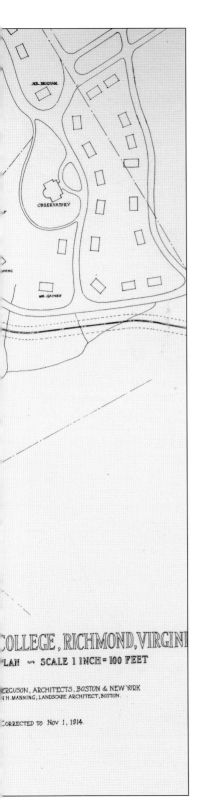

OLLEGE, RICHMOND, VIRGIN
LAN ~ SCALE 1 INCH = 100 FEET

ERGUSON, ARCHITECTS, BOSTON & NEW YORK
H. MANNING, LANDSCAPE ARCHITECT, BOSTON.

CORRECTED TO Nov 1, 1914.

Notice that the northern end of campus in Cram's master plan identifies an observatory and faculty houses for Professors Gaines, Loving, Metcalf, and Brigham. Notice also that the student club and chapel were planned to be in the midst of dormitories and a "dormitory group." Cram articulated his desire to position the chapel close to the men's residence hall to make religious services an integral part of their lives. For years, chapel services were held in the Playhouse, since a chapel within the dorms as planned did not become a reality. In 1929, Cannon Memorial Chapel opened on the women's side near the Westhampton lake bridge. Finally, this plan provided for the buildings of a Professional School on the Richmond College side of the lake. (University Facilities.)

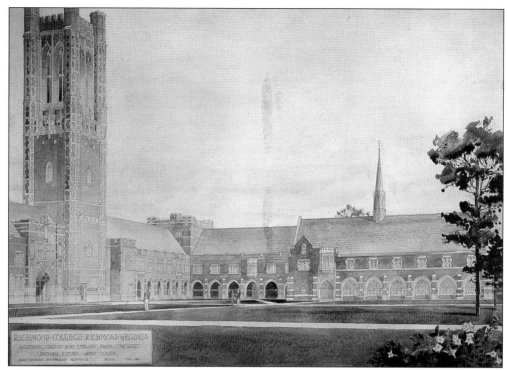

This architectural drawing indicates Ralph Cram's original plan for an extension of Ryland Hall. Due to financial restraints, the large edifice on the left was never built. Today Jepson Hall occupies the space in the general area across from Ryland Hall. (University Facilities.)

Ryland Hall was the most familiar landmark identifying the school prior to the construction of the bell tower on the Boatwright Memorial Library. President Boatwright's office was located in the bell tower of Ryland Hall, and it is said that he would ring the bell with a rope in his office, signaling the change of classes. (*Web.*)

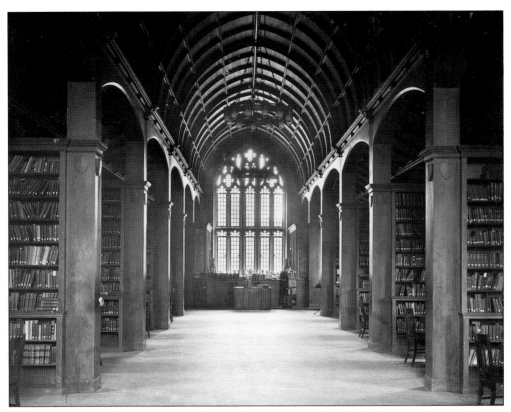

While a grand space for studying in Collegiate Gothic style, Ryland Hall's library rather quickly ran out of room with the expanding number of books in the school's collection. The wing of Ryland Hall with the library was named for Charles Ryland, the librarian and treasurer for the school. The wing with President Boatwright's office and the bell tower was named in honor of Richmond College's first president, Robert Ryland, who was the uncle of Charles Ryland. The English department occupies the space presently. (Above, Dementi Studio; below, University Facilities.)

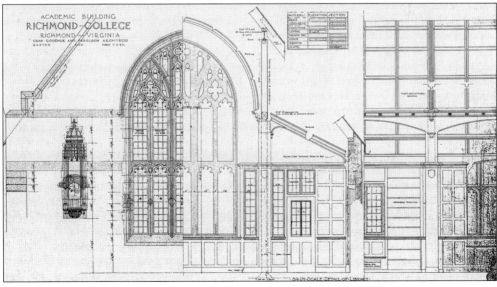

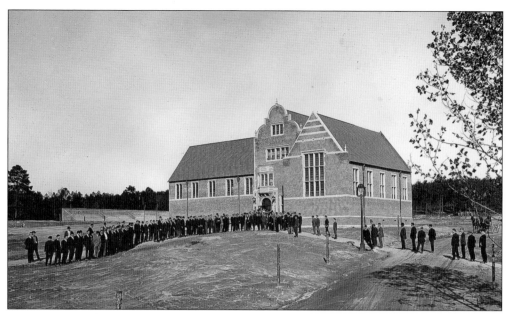

Serving as the refectory, Brunet Hall was one of the original buildings designed and constructed according to Cram's master plan. The stadium (also in the original plan) can be seen in the background to the left. (Dementi Studio.)

Gargoyles produced by master craftsmen are integral to the Gothic style and can be seen on buildings around campus. This close-up of Brunet Hall reveals a likeness of Cram with spectacles and a chiseled jaw. (Dementi Studio.)

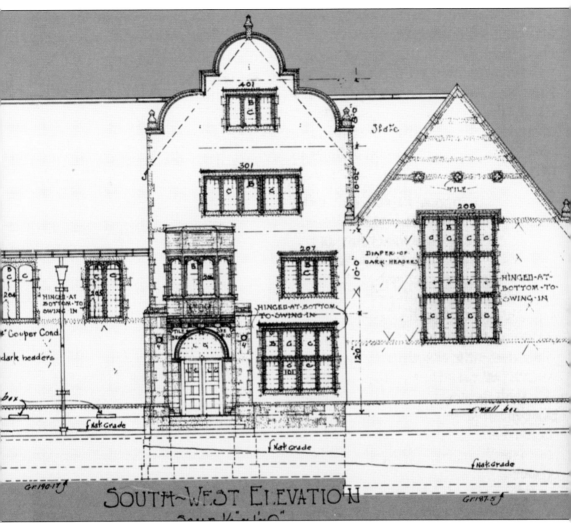

SOUTH~WEST ELEVATION

This is an image of the original architectural drawings of the Refectory. Using the traditional word refectory to describe the dining hall is in keeping with Ralph Cram's philosophy, as the origin of the word means to renew, and Cram believed that the "substance" and permanence of the architecture should be restorative for the students both physically and mentally. In 1924, the Refectory was renamed Sarah Brunet Memorial Hall. (University Facilities.)

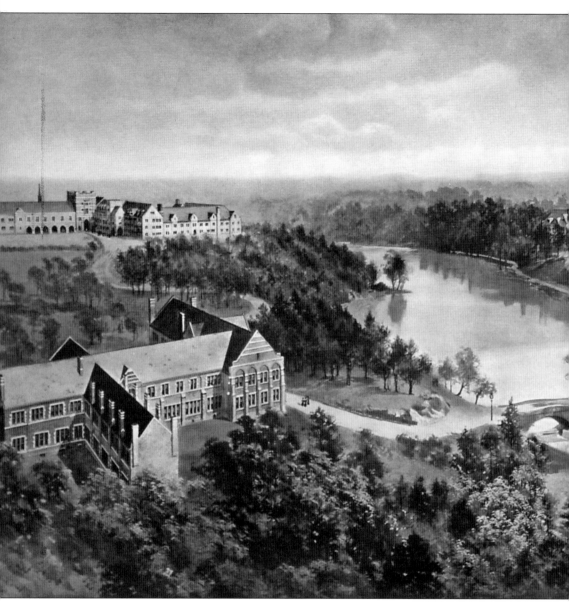

This engraving of Richmond College by Richard Rummell continues to be a popular rendering of the early campus. It is interesting to note the buildings that would not materialize as depicted in this drawing. First, a chapel sits on the hill where the Playhouse was located, which actually did serve as a chapel for years. However, Cannon Memorial Chapel was built instead on the hill on the other side of the lake, where one sees here a proposed academic building. Rummell's aerial

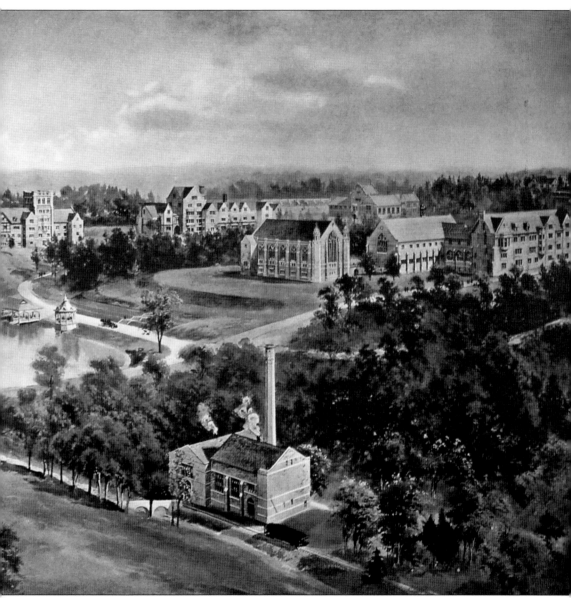

view (possibly sketched from a balloon) also shows the original structures that were actually built. They included the Westhampton College building (North Court), the Steam Power Plant, Ryland Hall, Jeter Hall, Thomas Hall, the refectory (named Sarah Brunet Memorial Hall in 1924), and the stadium (later First Market Field and the site of the new Robins Stadium). (Richard Rummell engraving.)

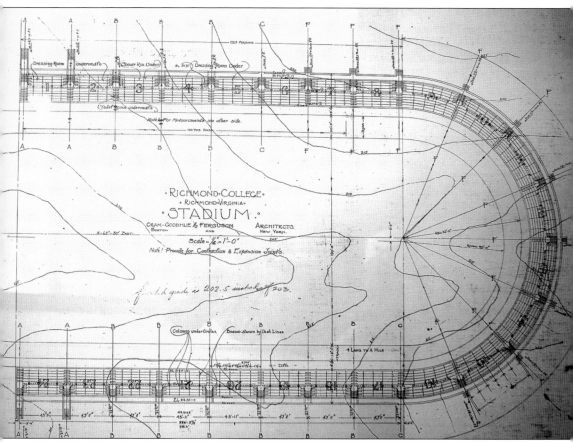

This drawing shows the original stadium plans, which were only partially implemented. Only the western stands were actually constructed, rather than the full seating surrounding the field. One can also see in these drawings plans for finished locker rooms under the stands. These amenities were added with the rededicating of the facility as the First Market Stadium to recognize the financial support of Bobby Ukrop. While this is the only original structure designed by Ralph Cram on campus to be demolished, it was for the cause of constructing the 9,000-seat E. Claiborne Robins Stadium on the site to open in 2010. The new stadium will be home for the football, lacrosse, soccer, and track teams. (University Facilities.)

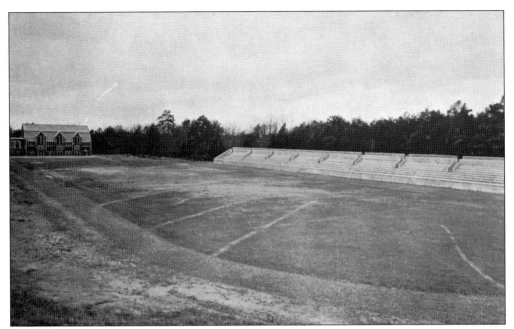

This wide view of the stadium shows the addition of Roger Millhiser Memorial Gymnasium, which was one of the last buildings to be completed with Cram as architect. Opening in 1922, the building was made possible by a donation from Clarence and Regina Millhiser in the memory of their son, who had attended Richmond College from 1913 to 1915. (*Web.*)

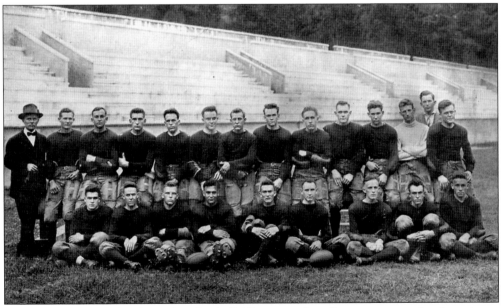

This is a team shot of early Spiders football. The original stadium on campus has been home to many teams over the years, including baseball teams led by coach Malcolm "Mac" Pitt and, most recently, to track and soccer teams as First Market Stadium. For decades, the space under the stadium, which was planned to be locker rooms, remained as cavernous spaces attractive to spelunking neighborhood children. The E. Claiborne Robins Stadium opens on this site in 2010 as a multi-sport facility for lacrosse, track, soccer, and football. (*Web.*)

43

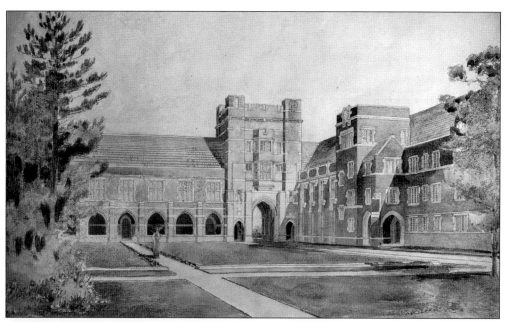

The Tower (briefly the name of Westhampton's yearbook) became a defining edifice for Westhampton College. This entire structure was simply known as Westhampton College until 1948. With an addition to the south, the arch and original building became known as North Court. The residence facilities would be home for various Westhampton College faculty and administrators, including Fanny Crenshaw, director of physical education, and Dean May Keller. President Boatwright would live here until the construction of the president's house on the north side of campus. This photograph depicts the garden interior space of the building, which is now known as North Court. (Above, University Facilities; left, Library of Virginia.)

In keeping with the Collegiate Gothic philosophy, landscape designer Charles Gillette developed private retreats for reflection and contemplation, which is best exemplified in the courtyards and gardens of Westhampton College, seen here under construction to be ready for the opening of the school in 1914. (Library of Virginia.)

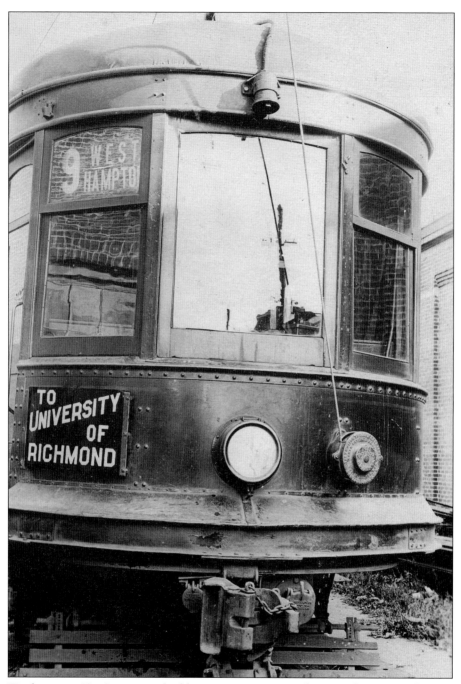

The Westhampton No. 9 streetcar had been transporting students to the campus for decades, stopping at the brick trolley stop built in the 1920s that still stands and continues to serve as a bus stop for the Greater Richmond Transit Company. Originally the gas-powered bus to replace the streetcar was greeted with enthusiasm, as seen in the *Collegian* headline in 1947, "Modern Buses Replace Trolley." It was seemingly a welcome announcement for the students, "who have been riding the noisy antiquated trolleys to and from campus." However, since then, many alumni have spoken of the trolley with nostalgia. (Reuben E. Alley.)

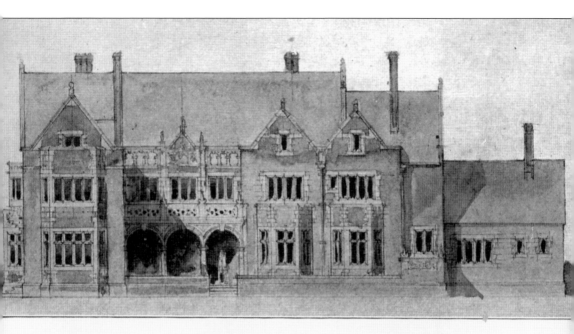

THE NEW COLLEGES—PRESIDENT'S RESIDENCE

The impressive structure for the President's Residence in this drawing would not become a reality. The original plan had designated the area near the trolley stop as faculty housing; however, the building in this drawing was planned to be positioned close to the power plant at the lake, providing proximity to both campuses. For a relatively brief period, President Boatwright lived in an apartment in what is now North Court prior to moving to a relatively modest university-owned house on the northern edge of campus. (*Web.*)

The Richmond Collegian

A SPIDER PUBLICATION FOR SPIDERS.

VOL. 1. RICHMOND COLLEGE AND WESTHAMPTON COLLEGE, WEDNESDAY, NOVEMBER 25, 1914. No. 1.

SPIDERS "LICK THE LOONIES."

Y. M. C. A. PROGRAM INSTRUCTIVE.

DR. MILLS SPEAKS ON "MISSIONS."

The Y. M. C. A. was especially fortunate last week in having such a speaker as Dr. John M. Mills, of Washington, D. C. Dr. Mills is a traveler of wide experience, who has visited many of the leading Christian mission stations of the Orient, and told of his impressions of their work, not from the standpoint of the representative of some Foreign Mission Board, but as a traveler. His address to the Y. M. C. A., "Missions from the View of a Tourist," was interesting and instructive. His address at chapel, Friday morning, on "Prospects and Progress in China," certainly opened the eyes of some of us to some things hitherto unthought of about that marvelous country. We only regret that we could not have heard more from Dr. Mills.

There will be no regular Y. M. C. A. meeting Thursday of this week, being Thanksgiving day. Next week we expect to have a dandy programme. (See announcement in the next issue of the RICHMOND COLLEGIAN.) The attendance was fifty-three last week. This was the low-water mark for the year. We want at least 100 men the Thursday evening after Thanksgiving.

We wish to call attention to the mission work in the city which our Y. M. C. A. is carrying on. Services are held regularly at the Soldiers' Home, the Home for Incurables, the City Home, and the State Penitentiary. This week we began services at the City Jail. If need continues, this work will be kept up, since these people appealed to us for help for the present. More men are needed to conduct this mission work efficiently. Are there not some Richmond College men, not at present engaged in some active Christian work, who will volunteer to help to carry a little sunshine to the inmates of these institutions? You need not be a ministerial student to do this. Every Christian man in College ought to have some definite Christian work in helping others each week. In case you should not be asked, any of the Cabinet members will help you to get in touch with the kind of work you prefer to do.

DEBATING COUNCIL SEVERS CONNECTIONS.

BRILLIANT PROSPECTS FOR A DEBATE WITH WAKE FOREST EXCITES INTEREST.

The Debating and Forensic Council was organized at Richmond College in May, 1913, with representatives for the following session were elected by each Literary Society. Dr. D. R. Anderson is President of the Council, W. R. Nelson is Secretary; G. T. Terrell and W. R. Nelson are representatives of the Mu Sigma Rho, and W. H. Brannock and E. N. Gardner of the Philologian Literary Society, for the session of 1914-'15. The object of the Council is to have charge of all joint matters between the two Societies. These are of two natures—

(Concluded on Page 3.)

R. C. WHITEWASHES W. & M.--SCORE, 32-0.

Successful Catapult-Like Plunges Make Game Child's Play for Spider Machine.

The Richmond College machine crushed up and down the field at will Saturday afternoon, November 21st, scoring in every quarter, and finally rolling up the score to 32 to 0.

The one-sided score would not indicate that the game was especially interesting to the spectators, but to the band of Spider "rooters" it was intensely. A mean cold wind swept across the gridiron, and chilled the men and women huddled in the grand-stand. Consistent "rooting" was necessary to comfort.

DOBSON SAVES REGULAR BACKS.

Coach Dobson used his 'Varsity men sparingly, fearing to risk injury at this epoch. The wisdom of such action is easily realized. They will be needed in the final and climactic clash next Saturday.

Forward passes and end runs were the order of the day. For William and Mary, Bertschey and James starred in this style of play, while Pollard, Cosby, and C. Wicker ran amuck the entire game.

GAME CALLED AT 2:30 P. M.

Promptly at 2:30 o'clock the game began, with Richmond College defending the east goal. Bertschey kicked off, and Pollard, receiving the ball, ran it up ten yards. Cosby, on the first play, made about two yards through the line. On the next try Pollard failed to gain, and C. Wicker punted to the thirty-yard line. The whole Spider team rushed down the field, Bertschey fumbled, and J. Wicker fell on the ball at our ten-yard line. In the second attempt for goal Cosby, from a shift play, pulled off a beautiful run around left end for a touchdown. C. Wicker kicked goal. Score—William and Mary, 0; Richmond College, 7.

The William and Mary forwards seemed unable to withstand the heavy charging of our backs. Just before the first quarter ended Bertschey punted, C. Wicker received the ball and ran it up eight yards. The quarter-back called for the old reliable "tackle around," W. Robbins responded nobly, and tore off thirty-five yards. Time was called, and goals changed.

NEWTON AND ROBBINS WIN TWO MORE TOUCH-DOWNS.

In the second quarter Pollard brought the crowd to their feet by a magnificent end run of twenty-five yards. The interference was perfect. First down and goal to gain. Robbins won five yards on "tackle around." The next try Robbins tore through for a touchdown. C. Wicker failed at goal. Score, 13-0.

In this quarter was shown the value of the knack of picking up the ball on the dead run, which Dobson has tried so hard to perfect. On the fourth down, with fifteen yards to gain, Bertschey's punt was blocked, Newton seized the ball on

the run, and went over the line for the third count. C. Wicker kicked goal. Score, 20-0.

No more touch-downs were made during the first half.

FUMBLE COSTS WILLIAM AND MARY A GOAL.

At the beginning of the second half Richmond lined up, defending the east goal. C. Wicker kicked off, and the agile Bertschey, receiving the ball on the run, gave a pretty exhibition of broken field running, carrying the ball up twenty yards. After futile attempts to advance the ball, the visitors were obliged to punt, and Cosby ran it back five yards. Then Cosby pulled off another brilliant run of fourteen yards. Polly made it fifteen more around right end, but Richmond College was penalized for holding. C. Wicker punted, and Bertschey fumbled in receiving. Privett grabbed the ball and started for the William and Mary goal, thirty-five yards away. He out-distanced his pursuers, and fell across the line with the oval for the fourth touch-down. Goal was missed. Score, 26-0.

WILLIAM AND MARY ARE GAME TO LAST.

Beginning the fourth period of play, the William and Mary warriors, tired and battered, took their places slowly, but gamely battled. On the first attempt for goal, with the ball on the five-yard line, Polly tore through tackle for the last count. Considering the bad angle, C. Wicker made an excellent attempt to kick goal, but failed. Score, 32-0.

The rest of the game the ball see-sawed up and down the field, resting in the shadow of our goal when the whistle blew.

Here are some of the statistics of the game:

William and Mary fumbled five times; Richmond College twice. On line plunges, we gained 131 yards; William and Mary, 26. On end runs, we registered 186 yards gained, to 76 for the visitors. We were penalized eight times, for a total of 90 yards; while William and Mary lost only 5 yards. William and Mary executed two successful passes, for a gain of 45 yards, and failed on four; we succeeded in four passes, that netted us 63 yards, and failed on three. During the game Richmond College made 16 first downs to their opponents 7.

THE LINE-UP.

Richmond College.	Position.	William and Mary.
Privott	L. E.	Cary.
Coburn	L. T.	Taylor.
Oakes	L. G.	Stone.
J. Wicker	C.	Copeland.
McNeil	R. G.	Page.
Robbins	R. T.	Wallace.
Newton	R. E.	Bothwell.
C. Wicker	Q. B.	Bertschey.
Cosby	L. H. B.	West.
Pollard	R. H. B.	Wyatt.
Roden	F. B.	Gale.

(Concluded on Page 4.)

FRATS ENTERTAIN PROSPECTIVE PLEDGES.

MANY FEEDS, SHOWS, AND PARTIES ENJOYED BY FRESHMEN.

The five days from the 15th to the 20th of November were gala days for men bidden to join the various fraternities. Nearly every night some one of the "frats" were entertaining their prospective "goats". Studies were more or less exiled from thought, and all attention was concentrated upon showing the new men a good time.

SIGMA PHI EPSILONS AT STUMPF'S.

The Sigma Phi Epsilon fraternity chose Stumpf's as a "get together" location Thursday night, the 19th. All of the active Chapter were present, a number of prominent alumni, and several Freshmen. The order of the evening was "eats" in great quantity and speeches in great number. There were speeches full of "pep" by W. L. Phillips, their Grand Secretary; Caspar Jones, of Richmond Academy's faculty; Dr. Frank Brown, Frank Louthan, and others. At a late hour the party dispersed, satisfied.

KAPPA SIGMAS IN THREE AFFAIRS.

The Kappa Sigs had their prospectives out thrice during the week. Monday night the active Chapter, prospectives, and several alumni occupied a box at the Bijou. They report a happy, jovial two hours. Thursday night three automobiles carried the same good time artists to Ashland, where the Randolph-Macon Chapter received. All kinds of "eats" were served, songs were rung, and so on, as is customary at a "frat" reunion. Not until the "wee sma's" were upon them did they prepare to depart. Saturday night the alumni of the "frat" gave the active Chapter and Freshmen a banquet at the Hermitage Club.

KAPPA ALPHAS "FEED" AT COUNTRY CLUB.

The Country Club of Virginia was a brilliant rendezvous for the Kappa Alphas Saturday night, when they herded up their "goats" and thitherward escorted them. All of the active Chapter and a number of alumni from this and other Chapters were there to make merry. The table was bedecked in crimson and old gold, the "frat" colors, and, better still, was set with delectable viands. Mr. A. Taylor Pitt acted as toast-master. During the evening some of the fellows were fortunate to find feminine friends who were willing to trip the light fantastic with them. All said it was a jolly affair.

PHI GAMMA DELTA STUNTS ENJOYABLE.

The "Fijis" entertained prospective pledges twice during the past week. Miss Ethel Whittet entertained for them Tuesday night. About thirty people (girls and boys) were present. Everybody was in his jovial mood. Simple games were played and old songs sung. Dainty refreshments were efficiently served. It was a "get together and be acquainted" party, whose success was evident to smiles. Friday night the male

(Concluded on Page 4.)

Students launched the *Richmond Collegian* newspaper in 1914. The voices of many generations printed in this newspaper provide a primary resource for the attitudes and events of the past. The Spiders' victory over William and Mary sparked the opportunity for this alliterative headline in the first volume of the newspaper, published on November 25, 1914. In an article appearing in 1939, on the 25th anniversary of the newspaper, the editors consider the role of the paper as a means of recording the life and character of the school. "The weekly will tell what else we do here—how we are progressing—our 'pep', if you will. How else are men to know?" (The *Richmond Collegian*.)

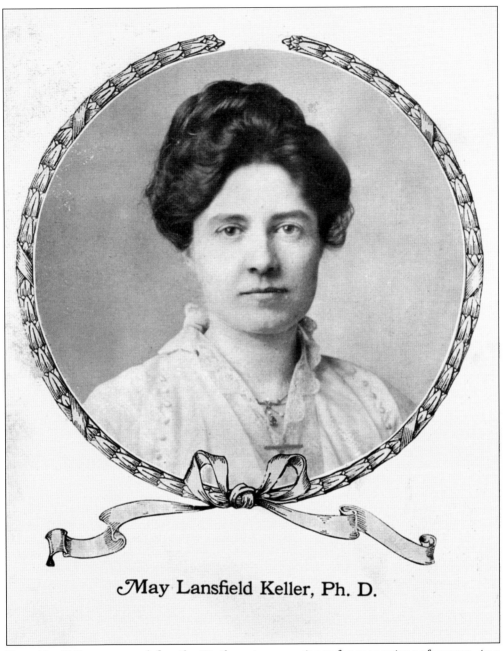

May Lansfield Keller, Ph. D.

Dean May Keller came to define the Westhampton experience for generations of women. As a strong leader and scholar in the esoteric field of medieval weaponry, Keller was responsible for the success of Westhampton College during her tenure from 1914 to 1946. She was known to have inspired great loyalty and respect. (*Web.*)

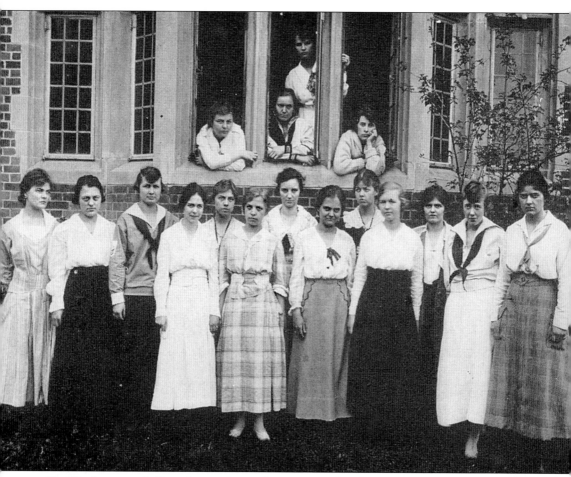

The Westhampton Suffrage League is seen here, pictured in the 1918 *Tower* yearbook. An article in the *Collegian* in the fall of 1917 entitled "Equal Suffrage League Entertains" reported that during the meeting, "inspiring speeches were made by Mrs. Lila Valentine and Dean Keller." The leadership of strong and capable women, beginning with Keller, became a Westhampton tradition. A prominent artist and leader in art education, Westhampton alumna Theresa Pollak founded the School of Arts at Virginia Commonwealth University. The first woman elected attorney general of Virginia, Mary Sue Terry, graduated from Westhampton in 1969. Of different generations, the two women are prominent examples among many Westhampton alumnae who have made major contributions to the community and the nation. (*Web.*)

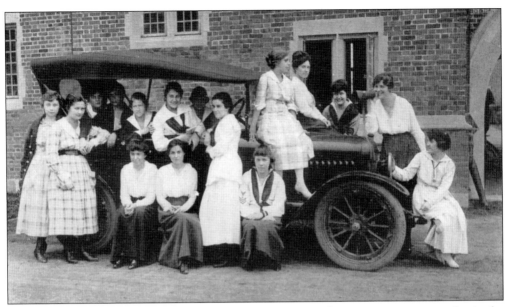

The Ford Model T became a symbol of freedom for these Westhampton women appearing in the *Tower* yearbook for 1918, which also featured student efforts for women's suffrage. (*Web.*)

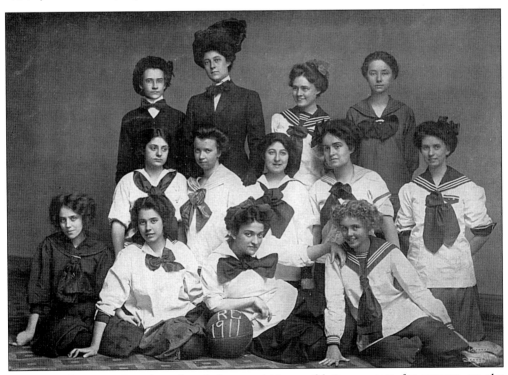

While coach Fanny Crenshaw founded an ambitious athletic program for women on the Westhampton campus, women did previously play for Richmond College downtown, as is clear from this photograph from 1911. The familiar uniform, replete with the large bow, would continue to be the tradition with the opening of Westhampton College in 1914. (Virginia Baptist Historical Society.)

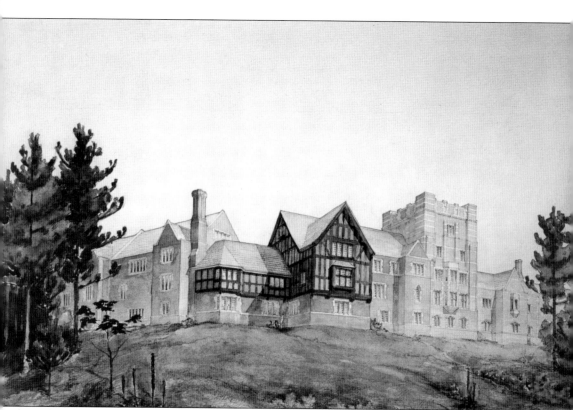

This drawing shows Thomas Hall, one of two original men's dorms. Cram positioned the building to overlook the lake atop one of the hills that characterize the campus terrain. During World War I, Thomas Hall served as barracks for nurses and enlisted men taking care of wounded soldiers on campus. During World War II, the building acted as the dorm for students in the U.S. Navy V-12 officer training program. (Virginia Baptist Historical Society.)

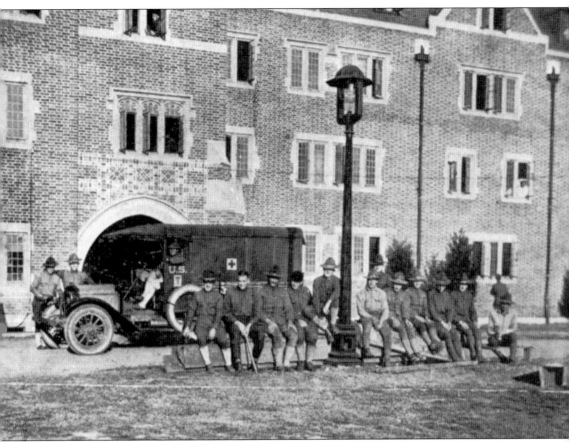

Shortly after the move to the western campus, World War I interrupted studies for Richmond College students. The school leased the campus facilities to the U.S. Surgeon General's Office, and it served as a hospital designated as Debarkation Hospital No. 52. According to U.S. Surgeon General's Office records, North Court housed 350 patients and Ryland Hall housed 200 patients, while Thomas and Jeter Halls "across the ravine" were used for 100 nurses and barracks for enlisted men. The dance hall pavilion was converted into a "two story ward" for 100 patients. For the war period, students moved back downtown, ironically using space in St. Luke's Hospital. Back downtown, one student in the yearbook lamented the dirty urban air after being treated to the bucolic winds of Westhampton. (*Web.*)

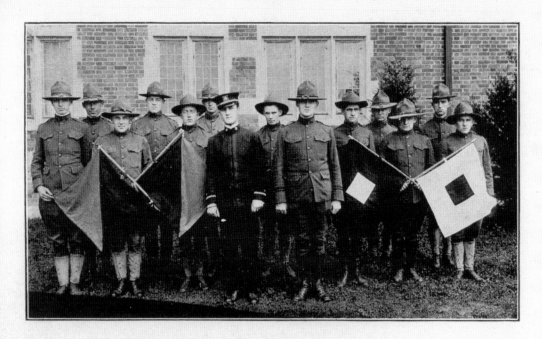

The Signal Corps

Seeing "a khaki-uniformed student body on the campus green," students in the yearbook describe the signal corps experience on campus during World War I. "The military work of this year may be said to have added a certain amount of spice to the conventional course of college life . . . double-timing up and down the Three-Chopt road . . . Spiders crawl out of their beds to answer the breakfast call." (*Web.*)

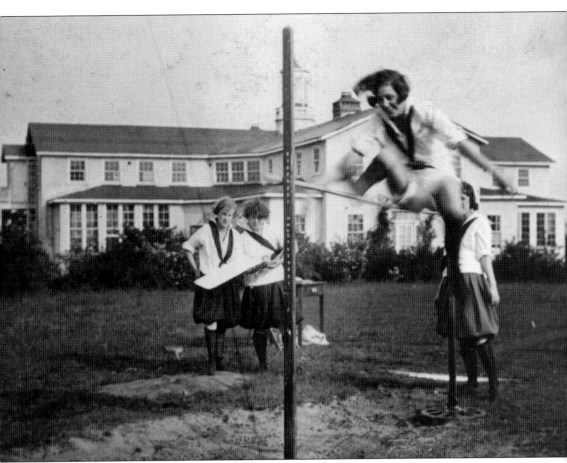

Westhampton physical education classes were held in the Red Cross building seen in the background. When the campus was leased as a hospital during World War I, the Red Cross building was erected on the Westhampton side near the present site of the Modlin Center. As reported by the *Collegian*, the multipurpose structure through the years saw vaudeville acts, proms, puppet shows, religious services, and university plays. The structure was demolished in 1936. (Virginia Baptist Historical Society.)

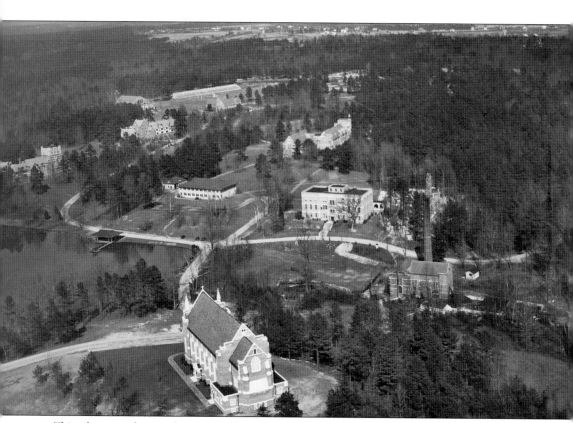

This photograph provides an excellent view of the Playhouse on the hill where the Boatwright Memorial Library was erected in 1955, as well as Cannon Memorial Chapel, which opened in 1929 overlooking the lake. Over the years, the Playhouse served as the chapel, a facility for commencement ceremonies, and the stage for school plays. It was also the spot for the student store and Slop Shop before they moved to the post office building, which is now part of Weinstein Hall. (Dementi Studio.)

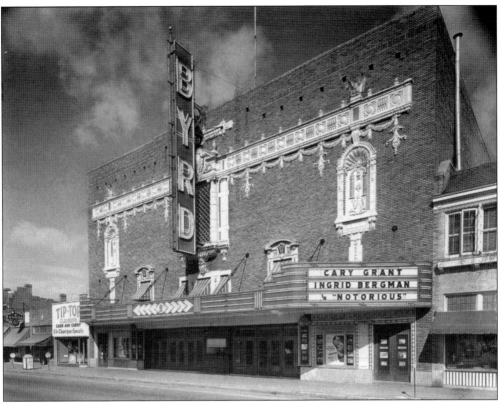

Built in 1928, the Byrd Theatre was regularly the site for University of Richmond activities. In 1929, students gathered for "University Night," with the Glee Club and band giving a peppy program consisting of numerous college songs. The tradition continued in 1951, as a pep rally was held at the theater with freshmen gathering at the corner of Boulevard and Grove Avenue wearing rat caps and bow ties. (Library of Virginia.)

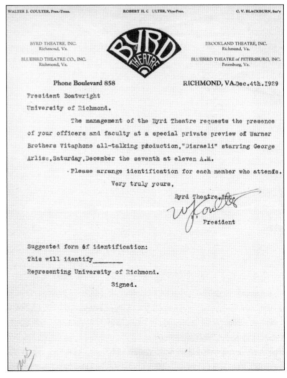

WALTER J. COULTER, Pres.-Treas. ROBERT H. C. ULTER, Vice-Pres. C. V. BLACKBURN, Sec'y

BYRD THEATRE, INC.
Richmond, Va.

BROOKLAND THEATRE, INC.
Richmond, Va.

BLUEBIRD THEATRE CO., INC.
Richmond, Va.

BLUEBIRD THEATRE of PETERSBURG, INC.
Petersburg, Va.

Phone Boulevard 858 RICHMOND, VA. Dec. 4th. 1929

President Boatwright
University of Richmond.

The management of the Byrd Theatre requests the presence of your officers and faculty at a special private preview of Warner Brothers Vitaphone all-talking production, "Disraeli" starring George Arliss, Saturday, December the seventh at eleven A.M.

Please arrange identification for each member who attends.

Very truly yours,

Byrd Theatre, Inc.

President

Suggested form of identification:
This will identify_____
Representing University of Richmond.
Signed.

The movie for University Night in 1929 was *The Time, the Place and the Girl*, a Warner Brothers Vitaphone all-talking production, as was *Disraeli*, the feature mentioned in this invitation to President Boatwright. (Presidential correspondence of Frederic W. Boatwright.)

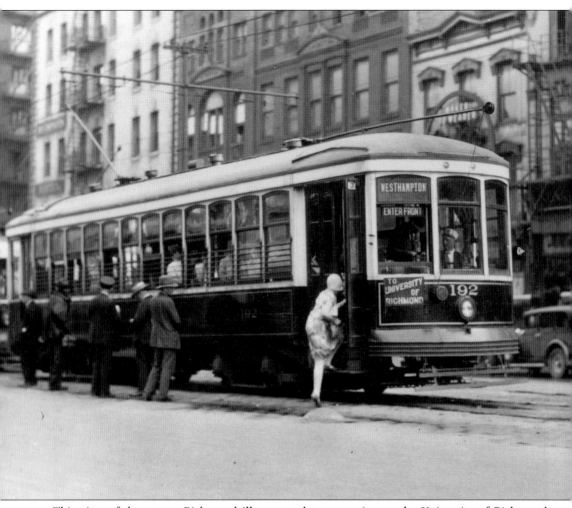

This view of downtown Richmond illustrates the connection to the University of Richmond by streetcar. In a 1916 letter, President Boatwright considers plans for downtown Richmond. "We own suitable property in the heart of the city," and therefore, he considered "proposing that we establish there a School of Law and Business Administration, doing the teaching in the afternoons and evenings." (Library of Virginia.)

The City of Richmond financed the city stadium as a civic improvement project in 1929. The University of Richmond arranged a long-term lease with the City of Richmond in the 1980s for $1 per year plus annual maintenance of the stadium. The 2009 season was the last the Spiders would play in the city stadium, as the team would come back on campus in 2010 with the opening of the E. Claiborne Robins Stadium. In addition to the recent 2008 season leading to a NCAA championship, the 1968 season was one of the more exciting in the history of University of Richmond Stadium, as the Spiders beat William and Mary, which would send the team to the Tangerine Bowl in Orlando, Florida, where it was victorious with quarterback William "Buster" O'Brien and All-American receiver Walker Gillette. (Both, *Web*.)

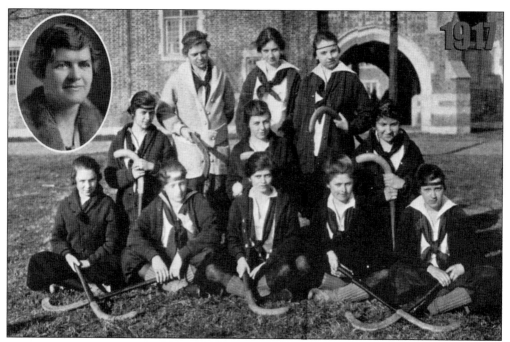

Fanny G. Crenshaw founded and directed the physical education program at Westhampton. On the faculty for 41 years, she coached archery, basketball, tennis, and track. Crenshaw was the first woman to be inducted into the University of Richmond Hall of Fame. (*Web.*)

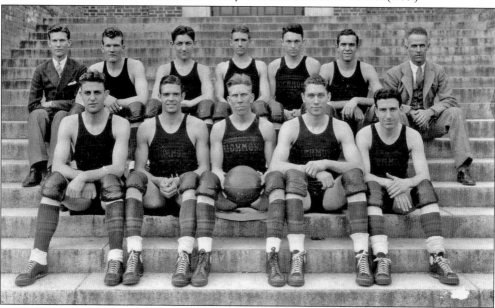

Coach Malcolm "Mac" Pitt (far right) holds the record for leading the only undefeated basketball team in Spiders history, as he led the 1934–1935 Spiders basketball team, pictured above, to a 20-0 record. As a defining force for the school's athletic program, Pitt Field is a tribute to an impressive career that lasted 43 years. Over the years, he worked as assistant football coach from 1928 to 1933, basketball coach from 1933 to 1953, and baseball coach from 1935 to 1972. In addition, he was athletic director from 1941 to 1967. (Virginia Baptist Historical Society.)

Providing a view of the study areas in the Ryland Hall library, this photograph was shown with others in the Virginia exhibit at the 1939 World's Fair in New York. Ryland Hall was dedicated to Robert Ryland and to his nephew Charles H. Ryland, a trustee, treasurer, and librarian of Richmond College. Garnett Ryland was professor of chemistry and son of Charles Ryland. He is seen leading the procession on the cover of this book. (Library of Virginia.)

This photograph of a student film club on campus was displayed in the Virginia exhibit for the 1939 World's Fair in New York, which was in keeping with the technology theme of the fair, heralded as the world of tomorrow. In recent years, the University of Richmond has sponsored the International Film Series and cosponsored with Virginia Commonwealth University both the French Film Festival and the China-America Festival of Film and Culture. Supported by the donation of 300 scripts to the school, in the spring of 2010, students could select the new major of film studies. (Library of Virginia.)

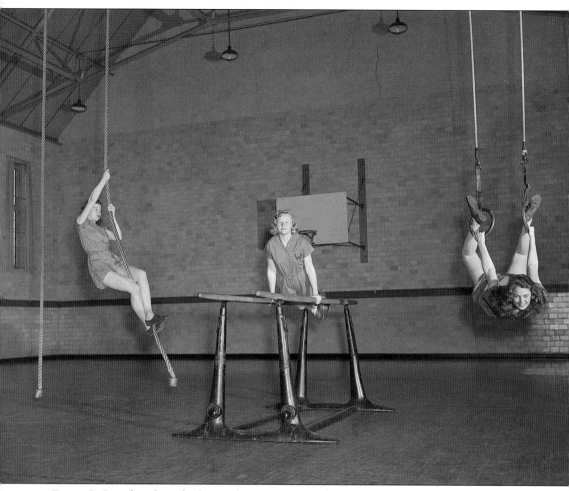

Fanny G. Crenshaw launched an ambitious program for Westhampton women as the director of physical education in 1914; however, for years, a gymnasium was not built to match the caliber of the program. Classes met in the Red Cross building that was left behind by the U.S. Surgeon General's Office, which transformed the campus to a hospital during World War I. The tower of the main building of Westhampton (now North Court) also served as a gym. The need to build a gym became even more evident as a degree in physical education was created as a new offering in the 1930s. In 1936, the Gymnasium and Social Center Building at Westhampton College opened. However, most students over the years would know the structure as Keller Hall, as it was rededicated in 1946 to honor the retiring Dean May Keller. This image provides a good view of the gym's interior, which was two stories high with an observation level to watch action on the floor. Finally, Westhampton students had a proper gym to practice and compete, with locker rooms, an office for the director of physical education, and a trophy room. A pool named in honor of Crenshaw opened in 1963 as an addition to the gym and Keller Hall. (*Web.*)

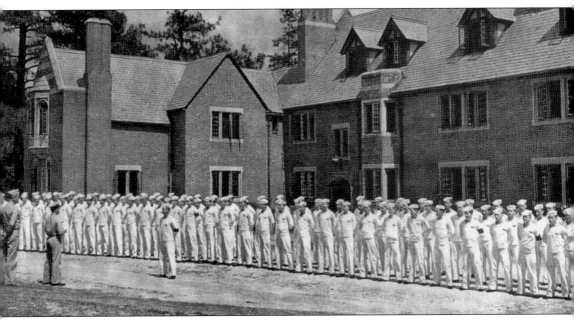

During World War II, the University of Richmond was the site of the U.S. Navy V-12 officer training program. Thomas Hall and Jeter Hall (pictured here) were used as dorms for the students, who became members of the campus community as well as athletes on the sports teams. The commanding navy officer in charge of the V-12 program was pictured in the yearbook along with President Boatwright and other administrators. (Virginia Baptist Historical Society.)

This photograph of airplane spotters appeared in the 1943 *Web* recognizing contributions to the war effort, with the caption, "Is that a P-38?" Public relations director and instructor of journalism Joe Nettles was the director of civilian air raid precautions. A 1942 *Collegian* article reported that 18 Westhampton women and Fanny G. Crenshaw had "volunteered to spot airplanes throughout the summer months in the absence of the men who had performed these duties since after the attack on Pearl Harbor." The women served four-hour posts watching for enemy planes on the roof of the chemistry building, which was rededicated as Puryear Hall in 1944. (*Web*.)

During World War II, the majority of the male students were serving in the conflicts overseas. In the spring of 1943, the University of Richmond began a close relationship with the U.S. Navy, with the launching of the U.S. Navy V-12 officer training program to be located on the University of Richmond campus. This humorous image appeared in the 1943 *Web*, running with the following caption, "Many times this year we have said good-bye to some of our boys as they left for camp. All of us can recollect the morning we sent the Army Reserves off on the streetcar. But the girls did their part to keep up the morale of the service men. Yessir! They also raised the morale of the midshipmen at the United State Naval Academy when they selected the Web Beauty for 1943." (*Web*.)

Three

A LOCAL UNIVERSITY
1946–1968

After World War II, the University of Richmond had a close connection to the city, as its enrollment consisted largely of students from Richmond and Virginia at large. The 1953 *Web* selected as its theme "Richmond, the City, and University." The editor of that year's annual, Irby Brown, would later work as a professor of English at the University of Richmond for many years. Another student who also came back to school as a professor, Dr. Stuart Clough, recalls that in the early 1960s, "most of my classmates were Virginians," remembering that, "the pines parking lot behind Richmond Hall was crowded with beat-up cars of commuter students."

The leadership of the school passed to a new president in 1946: George Modlin was a successful professor of economics and dean of the Evening School for Business Administration. Modlin had worked in earlier years with Boatwright to build greater cooperation between the School of Business Administration and the business community of the Richmond area. President Modlin led the University of Richmond at the beginning of a new era, with a student body filled with soldiers coming home from World War II whose education was paid for by the G.I. Bill. Many attended the Law School, which would find a new home on campus in a building dedicated in 1954. The Boatwright Memorial Library opened in 1955, and the Business School moved from the V-12 barracks to a new state-of-the-art building on campus completed in 1961. In keeping with the school's commitment to the city, University College opened in 1962 on Lombardy and Broad Streets, becoming a symbol of the school's presence and continued cooperation with the city's business community extending from the University of Richmond's Evening School of Business Administration.

During the 1950s and 1960s, traditions flourished. Westhampton women continued a spirited recognition of May Day, a celebration of spring, along with the symbolism of a daisy chain during Westhampton commencement. These events and many others were captured on film by the local Dementi Studio, which was essentially the school's photographer for years, as well as a Richmond institution that collected an archive of images documenting notable citizens, institutions, landmarks, and events in Richmond. The campus photographs recorded the ordinary and the exceptional. Time has made some of these everyday events seem curious as customs and fashions have changed. However, the photographs include those moments that students and the school felt important to capture for posterity and what they wanted to be the visual history of the University of Richmond.

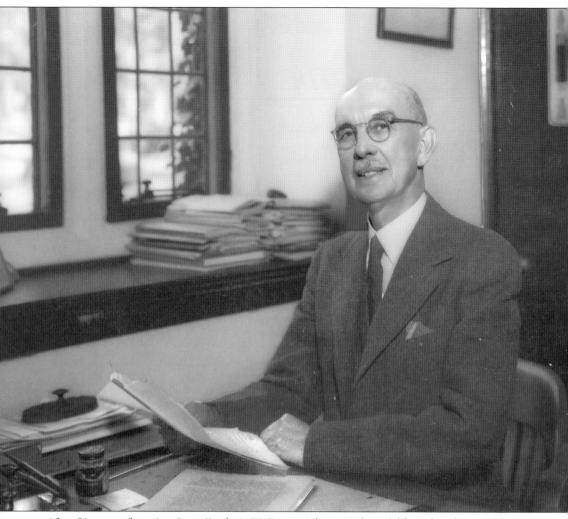

After 51 years of service, Pres. Frederic W. Boatwright retired in 1946, ending his presidency to serve as chancellor of university until his death in 1951. University of Richmond rector Douglas Southall Freeman articulated in a letter to Boatwright his thoughts on the impact and influence of Boatwright's exceptional career. "At this moment I can do no more than say to you that your record is written deep in the lives of thousands and in the very life of the South and nation." The letters written from Boatwright's desk over the years have been preserved and are available digitally through the Boatwright Memorial Library. (Library of Virginia.)

Two residence-style fraternity houses remain standing on campus. The Phi Kappa Sigma house pictured here still stands across from the Robins Center and is now known as the Pacific House. The original Kappa Sigma house is located in the same vicinity as the Atlantic House. In 1939, Dean Raymond B. Pinchbeck recommended that regulations for the fraternity boardinghouses include the "full time services of a house mother," along with the keeping of financial records, audited periodically. Eventually lodge-style houses built on Old and New Fraternity Rows replaced the residence houses. Sororities were introduced on campus in 1986. (*Web.*)

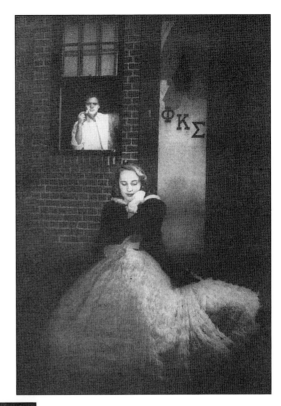

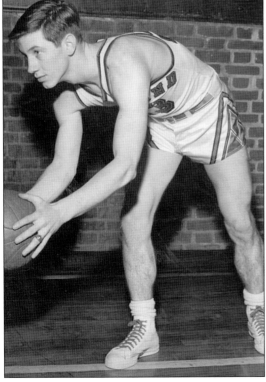

Warren Mills played for the University of Richmond from 1952 to 1955. A leading scorer in University of Richmond history, his jersey was the first to be retired by the school. A banner hangs in the Robins Center above the main court in a tribute to his career, alongside banners for Johnny Newman and Dick Tarrant. (University Athletics.)

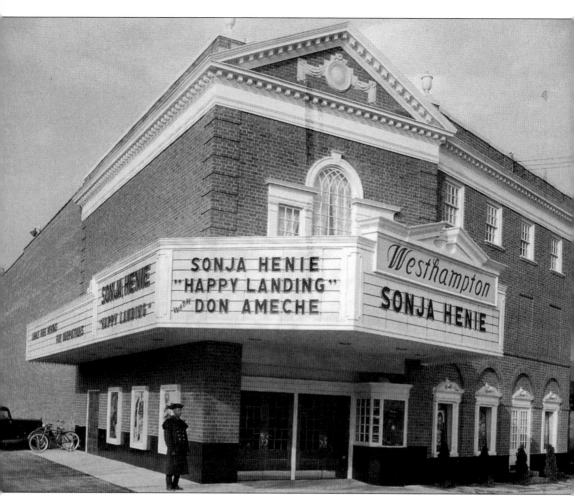

The Westhampton Theatre on Grove Avenue near the campus was a popular spot for student entertainment with its opening in 1938—the year *Happy Landing* with Sonja Henie and Don Ameche was released. This block became even more popular as a gathering place with the addition of Philip's Place in 1939. Both establishments were featured regularly in advertisements in the *Web* and the *Collegian*. In an advertisement for Philip's Place in 1949, students are invited to "lunch and dine . . . next to the Westhampton Theatre." The menu offered "steaks, chicken, chops, sandwiches for picnics and all occasions . . . specializing in homemade rolls and pies." (Dementi Studio.)

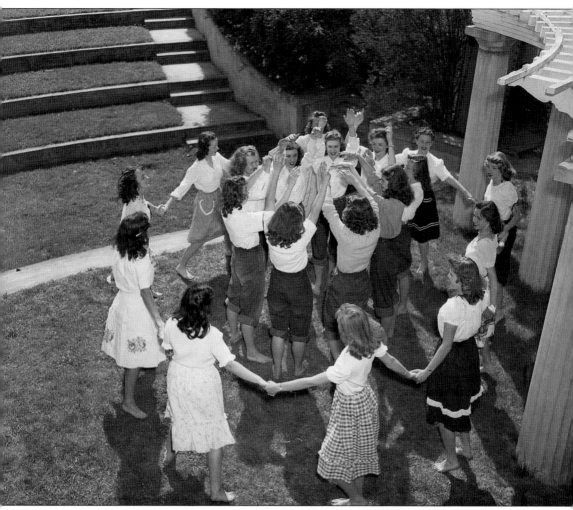

In this photograph, Westhampton women enjoy folk dancing in the Greek Theater in the 1940s. President Boatwright would have approved of this amusement; however, he was firmly against dancing between men and women. His opposition to dancing, which represented the views of the Baptist denomination, can be seen in a letter dated April 12, 1918. "I have pointed out what seemed to me to be the evils of dancing and have advised the students against indulging in this amusement. My attitude is well known at the college and in Richmond and in many parts of Virginia. On the other hand, I permit the young women of Westhampton Colleges, as a part of their exercise and also for their amusement, to dance with each other at any suitable time." Boatwright's opposition to dancing remained a concern he expressed in a 1939 letter, reporting on inappropriate behavior at a fraternity house on campus where "members of the fraternity entertained a number of unchaperoned women in the house, at which time they danced with the women," and further, "it does appear that one young woman removed her shoes and danced without them." (Dementi Studio.)

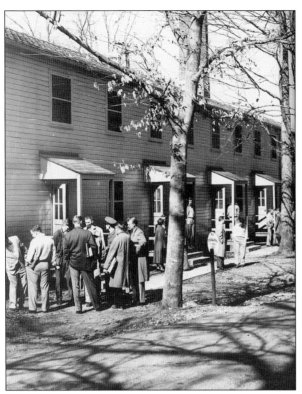

Beginning in the humble setting of the barracks built for the V-12 officer training program during World War II, this was the site for the Evening School of Business Administration prior the opening of the Business School building in 1961. The school would be renamed in 1979 as the E. Claiborne Robins School of Business Administration. Modlin led the development of the Business School from the barracks to the state-of-the-art building as president of the University of Richmond. Focusing on a connection to the city, the Business School student body is described in the 1959 *Web* as "the businessmen of the future preparing for a life's work in offices, stores, and industries . . . observing and practicing in the city as part of the school's preparation." (*Web*.)

George Modlin came to the University of Richmond with a doctorate from Princeton to become the dean of the Evening School of Business Administration as well as the chairman of the economics department. Becoming president after Boatwright in 1946, he launched the School of Business Administration and dedicated the new building in 1961. It was under his administration that the Law School found its home on campus and the Boatwright Memorial Library was built. In keeping with his interest in the changing face of business and education, it was under his administration that University College opened in 1962. As a tribute to his dedication to the arts, the Fine Arts Building, which was completed in 1968, was renamed the George M. Modlin Fine Arts Building upon the president's retirement in 1971. (*Web*.)

Buddy Mayo could be found in yearbook advertisements pictured as the proud proprietor of the Dry Dock, a lunch spot located on the ground floor of the Student Center along with the post office and college shop. The Student Center (in the Student Activities Building), which is now part of Weinstein Hall, opened in 1951 and included a recreation room and barbershop. As an attempt to replace the name "Slop Shop" for Mayo's previous establishment, a contest was conducted, and a student suggested "Dry Dock," reasoning that "in student vernacular it is dry and a good place to dock," according to the *Collegian* dated November 15, 1961. However, many students still referred to the food services as the Slop Shop. With the building of the Tyler Haynes Commons in 1976, the Dry Dock moved to that building. It was subsequently renamed twice, first as the Pier and then as Tyler's Grill, its current name. (*Web.*)

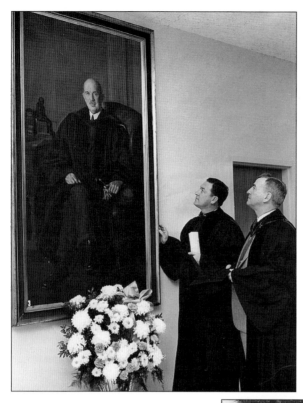

A trustee, the editor of the *Baptist Religious Herald*, and the chairman of the Virginia Baptist General Association Committee, Reuben E. Alley headed the memorial campaign to raise $500,000 for the building of the Boatwright Memorial Library. The Virginia Baptist General Association presented the new library as a gift to the University of Richmond. Alley is seen here on the right with Rev. Vernon Richardson unveiling the Boatwright portrait that would hang in the new library. A separate wing of the library to house the Virginia Baptist Historical Society was donated by the Woman's Missionary Union of Virginia. (Virginia Baptist Historical Society.)

This photograph was featured on the cover of a commemorative pamphlet for the opening of the library in 1955. Students are pictured on the hill of the new library, which was the site of the Playhouse (the last remaining building of the old amusement park). The Boatwright bell tower would become the landmark representing the University of Richmond, as Ryland Hall's bell tower had been in the early days. While Pres. Boatwright would ring the Ryland Hall bell at the change of classes, the bells of the carillon in the Boatwright library originally rang every hour, beginning at 8:30 a.m. Music would also come from the carillon, which was replaced with the electronic bells that now play daily at 12:30 and 5:00 p.m. Over the years, the bells became a familiar sound on the campus, along with the whistle of the train bringing coal to the old steam power plant. (Dementi Studio.)

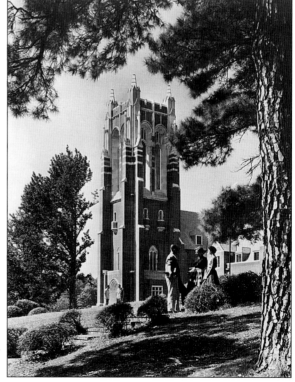

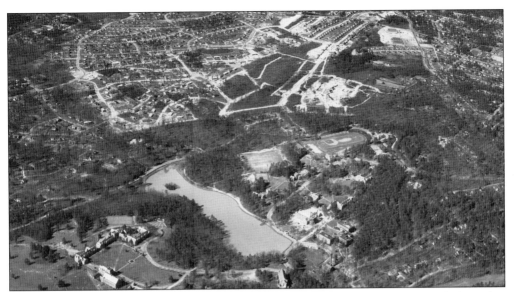

This aerial shot shows the building of the Boatwright Memorial Library, which was dedicated in 1955. The construction of houses to the west of the campus near the stadium, in the area known as College Hills, can also be seen in this image. Real estate developers were finding a market for new housing. A steady population shift from the city to West End suburbs had begun—a trend that continues to this day into the counties of Henrico and Goochland. Built on land annexed by the City of Richmond, the University of Richmond sits on the line between Henrico County and the city. (Virginia Baptist Historical Society.)

A time capsule is prepared for Boatwright Memorial Library as President Modlin inserts a portrait of Frederic Boatwright. The box was placed behind the large cornerstone marked "1954" at the base of the original tower. Likely not in the capsule but important to students in 1955 was the introduction of hair spray and the transistor radio. (Virginia Baptist Historical Society.)

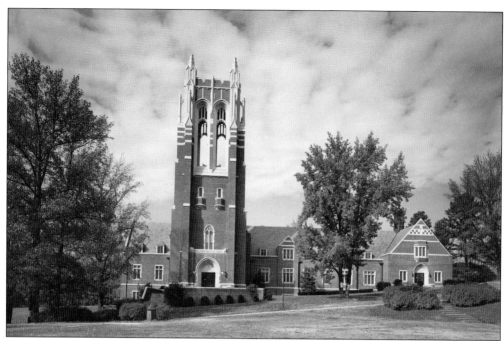

The entrance to the Virginia Baptist Historical Society can be seen on the right. It is the archives for Virginia Baptist history, which includes the history of the University of Richmond. The stories of the Baptists as defenders of religious freedom are told in documents and artifacts such as the lock and key of the Culpeper jail that imprisoned Virginia Baptists in the 18th century. It was this key that J. L. M. Curry, president of the board of trustees, raised to enthusiastic supporters of Richmond College during a speech calling for financial support to sustain the struggling school after the Civil War. (Above, Dementi Studio; below, Virginia Baptist Historical Society.)

The Rest of the Story

STORIES BEHIND THE OBJECTS

In this photograph, Westhampton women use cafeteria trays as sleds in the snow. This hill, overlooking the lake, was the site of the casino of the old amusement park. In recent years, and in warmer months, students referred to it as "Boatwright beach" for those wanting to study and take in the sun. (Dementi Studio.)

Pictured in the 1959 *Web*, this couple stands in front of the original campus stadium, which was the home for track meets, coached for 35 years from 1950 to 1985 by Fred Hardy. Hardy was also credited with introducing a form of tag football that came to be known as Hardyball to intramural teams. A 1971 *Collegian* article quips that "it looks as if Fred Hardy has acquired something that even eluded Dr. Naismith [the inventor of basketball]." (*Web*.)

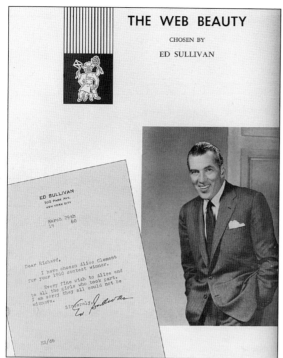

THE WEB BEAUTY

CHOSEN BY

ED SULLIVAN

ED SULLIVAN
502 PARK AVE.
NEW YORK CITY

March 29th
19 60

Dear Richard,
 I have chosen Alice Clement
for your 1960 contest winner.
 Every fine wish to Alice and
to all the girls who took part.
I am sorry they all could not be
winners.
 Sincerely, Ed Sullivan

ES/db

A long-standing tradition in the *Web* involved the editors finding a celebrity to select the "Web Beauty" for that year. In 1960, it was Ed Sullivan, who was a familiar face to Spiders and other Americans, as he appeared every Sunday evening at 8:00 p.m. on CBS. (*Web*.)

The fashion of these Richmond College class officers was the typical conservative business attire of young men in the early 1960s. Billboard's top 40 hits included the music of Bobby Darin, Elvis Presley, and Fabian. The Nixon-Kennedy debates became a first in television history. Americans were also watching the Westerns of *Gunsmoke* and *Wagon Train* on television. In business, David Ogilvy published the best seller *Confessions of an Advertising Man*. (*Web*.)

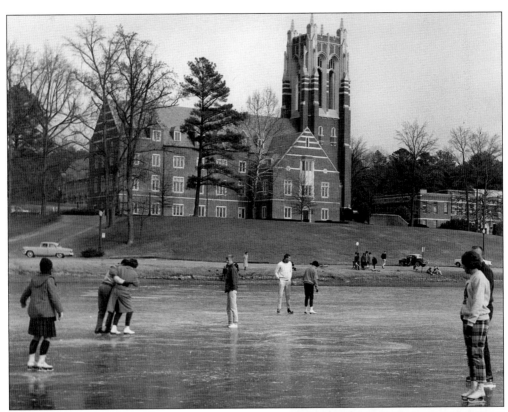

This photograph was published in the *Collegian* on January 11, 1963, reporting that the lake had been frozen since December. Skating on the lake has often been a dangerous activity, with a variety of warnings going back to a December 10, 1915, *Collegian* article when the editors were asked "to urge the men to keep old sticks, rocks, etc, off of the pond while it is freezing . . . the temptation is to test the strength of the ice by skimming a rock or large stick across the surface . . . think it over, and don't do it." (Dementi Studio.)

Students park to chat on campus. In a *Collegian* article of the same year (1957), the administration addressed campus traffic problems. "There is no parking problem on campus. The real problem is the re-parking of cars. Students who drive from one class to another cause our traffic problems." The superintendent of buildings and grounds offered a solution that has become the reality. "The best answer to the parking problem . . . would be to assign each place to a student in a numbered lot. His sticker would bear the number of his lot and place. He would not be allowed to park anywhere else on campus." (*Web.*)

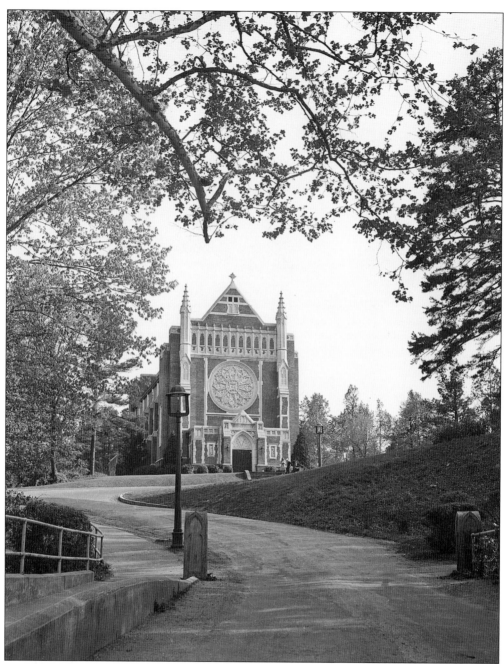

Seen in a view from the bridge, Cannon Memorial Chapel was made possible by a gift from Lottie Southerland Cannon, the wife of tobacco businessman Henry Mansfield Cannon. Ralph Cram's original plans had been to place a chapel among the men's dorms to make it a part of the students' daily lives. The Richard Rummell engraving places the chapel on the hill where Boatwright Memorial Library was built, replacing the Playhouse, which had served as a makeshift chapel. Westhampton women had attended chapel services in the Red Cross building, located near the current site of the Modlin Center for the Arts, constructed during the period the campus acted as a World War I hospital. (Dementi Studio.)

Prior to the construction of the Boatwright Memorial Library, Westhampton College students had limited access to Ryland Hall's library across the lake. A reading room was established in the dean's office in what would be called North Court after the opening of South Court. Students in this picture are taking time off on benches, which were removed at a later date. The ideals of Collegiate Gothic architecture were that the campus was to allow for cloistered areas to relax, reflect, and contemplate. (*Web.*)

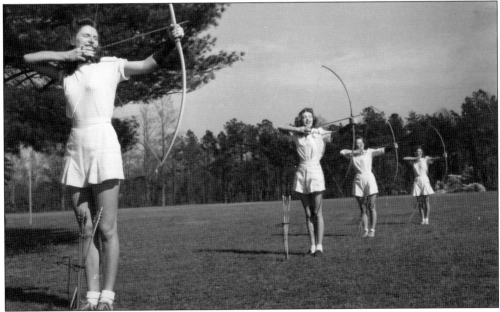

Coach Fanny Crenshaw had introduced archery as one of the appropriate sports for Westhampton women. In the spring of 1935, Dean May Keller submitted a request to President Boatwright to allow sports to be played on Sunday. The president granted permission; however, the sports were limited to archery and tennis, with play restricted to before 9:00 a.m. and from 2:00 to 6:00 p.m., feeling that this would allow for "a minimum of interference with the customs of other people and without such ostentatious publicity as might be prejudicial to the college." (Dementi Studio.)

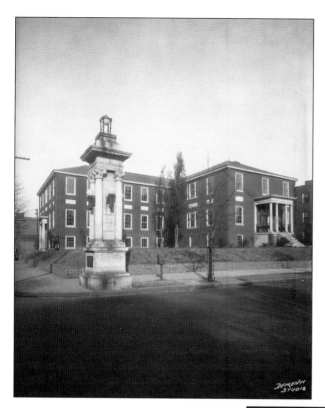

The Law School began holding classes in 1870. It was moved to the Westham campus briefly in 1914; however, it was moved back to the location in the old Columbia building at the corner of Grace and Lombardy Streets and would remain there until 1954, when a new building was dedicated on the western campus. (*Web.*)

In 1890, the family of T. C. Williams (right) provided funds to support the struggling Law School established in 1870. From that point on, the school was able to remain open as a place for mostly local residents to study the law. His son, T. C. Williams Jr. carried on the tradition in business and philanthropy. He was a trustee and benefactor of the school for a number of years until his death in 1929. A recognizable name in the Richmond community, T. C. Williams Jr. helped develop the Windsor Farms community, rebuilding his home, Agecroft Hall, from materials brought from a historic house built in England. (*Web.*)

This photograph provides a view of the Law School in the old Columbia building on the corner of Lombardy and Grace Streets. Below is a meeting of the Student Bar, which was an organization founded in 1939 to be the student counterpart of the Virginia State Bar Association. (Right, Virginia Baptist Historical Society; below, Dementi Studio.)

The new Law School Building was dedicated on October 15, 1954. It was greeted by Hurricane Hazel, which hit the campus with high winds and rain, challenging those gathered for the ceremonies; however, participants persevered. The day's activities were not cancelled, and the building officially opened on that fall day. The new structure included a new law library, pictured below. (Both, Virginia Baptist Historical Society.)

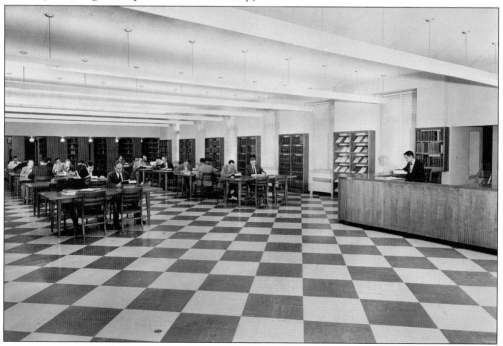

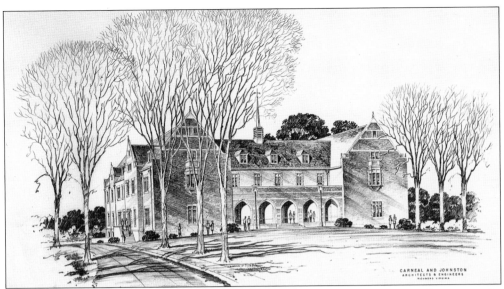

From these plans and beginnings for the Modlin Fine Arts Building, the Modlin Center for the Arts complex now incorporates several state-of-the-art theaters, along with the world-class University Museums, which include the Lora Robins Gallery of Design from Nature, the Joel and Lila Harnett Museum of Art, and the Joel and Lila Harnett Print Study Center. (Virginia Baptist Historical Society.)

Dramatic productions by the University Players began on the old campus. However, a building was not specifically erected for theater productions prior to the opening of the Fine Arts Building in 1968. Shows were presented regularly in the Red Cross building and on stages constructed in the Playhouse, where Boatwright Memorial Library now stands. The first production in 1968 in the Fine Arts Building was *Oliver*, which cast some faculty children as Fagan's gang. In that building, a strong program was developed under the leadership of Professors Bill Lockey and Jack Welsh. Grant Shaud, a drama student in the 1980s with Lockey, found success in Hollywood in a starring role on the sitcom *Murphy Brown*. The University of Richmond's place in the arts can be credited to the dedication and leadership of both Pres. George Modlin and Pres. Richard Morrill. The Modlin Center for the Arts opened in 1996, during the Morrill administration. (*Web*.)

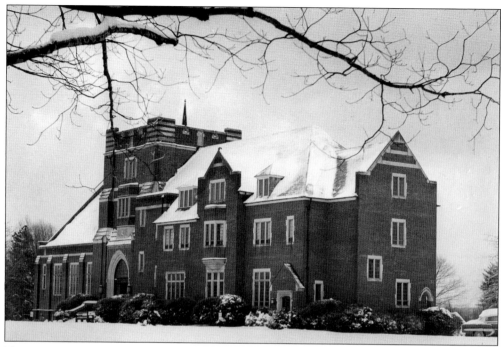

The original name of this building, dedicated in 1936, was the Gymnasium and Social Center Building at Westhampton College. It was renamed Keller Hall in honor of May Keller upon her retirement in 1946. A wing for a pool was added in 1963 to be named as a tribute to Fanny G. Crenshaw, founder of the physical education program at Westhampton. The reception room, decorated with Elizabethan furniture, has provided a grand meeting place for years and served as the location for faculty meetings. The ground floor was an important area, serving as a student center for Westhampton students. It included a bookstore and tearoom (shown below) that opened onto a formal garden planned by Charles Gillette. (Above, Dementi Studio; below, Library of Virginia.)

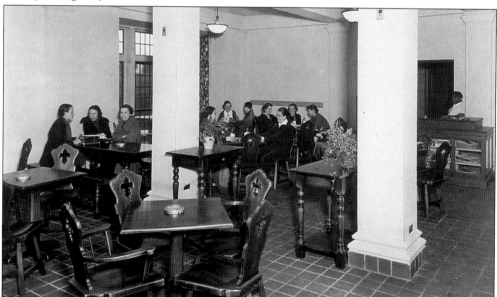

This is a photograph of the Crenshaw pool ground-breaking ceremony. From left to right are Dean May Keller, Dean Marguerite Roberts, Frances Anderson Stallard (class of 1928), and Leslie Sessoms Booker (class of 1922). (Dementi Studio.)

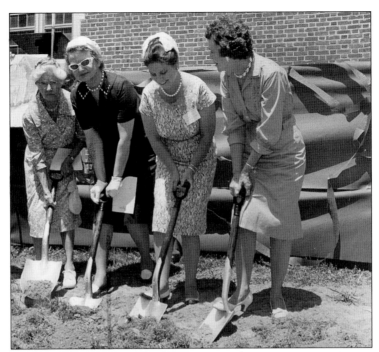

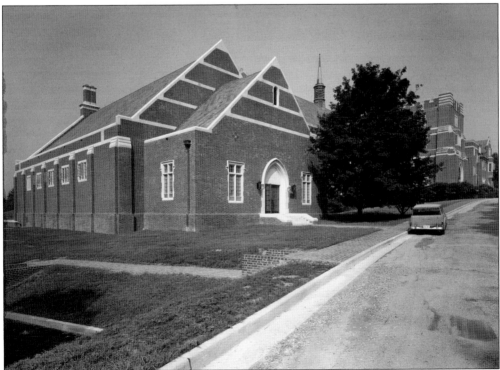

Keller Hall is pictured as seen from the east, showing the entrance to the Crenshaw pool, which was added in 1963. The pool continued to be used with the opening of the Robins Center in 1972. This section of Keller Hall was altered significantly with the eventual closing of the pool and the construction of the George M. Modlin Center for Arts in 1996. (Library of Virginia.)

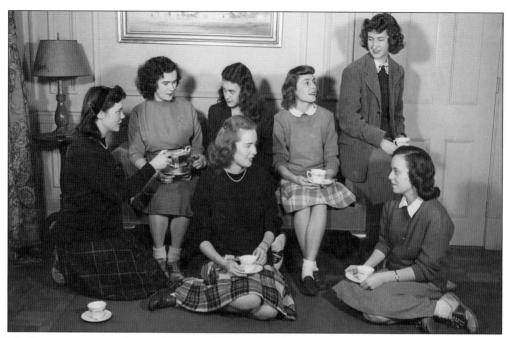

Westhampton women founded Nostrae Filiae in 1936 as an organization to retain ties with the alumnae of the Richmond Female Institute and the Women's College of Richmond. Members are pictured here in the 1947 *Web* with the following caption: "The name may have changed and the location may be different but the ideals and traditions cherished by those who have gone before are now entrusted to their daughters, so the members of Nostrae Filiae will become the citizens and leaders of the world of tomorrow." (*Web.*)

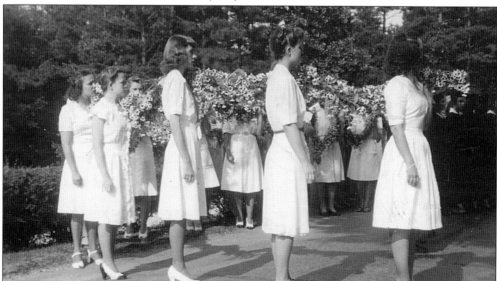

Dean Keller started the daisy chain tradition in 1915 to be a symbol of the bond between the Westhampton sophomore and senior classes as part of the graduation exercises in the spring. The daisies represented "the endless chain which reaches through the years." While Westhampton women have not continued the ritual of forming a daisy chain from the fields on campus, the symbolism of the daisy chain lives on in the Proclamation Night ceremonies. (*Web.*)

This photograph appeared in the 1943 *Web* with the caption "This year our living has been greatly altered and our social life changed because of a win-the-war effort toward which we have all pledged ourselves." While world events changed drastically, this scene of the brick streetcar stop and path has endured with little alteration. After the war, the bus system replaced the streetcar, as commuters continued to make up a large portion of the student body in the 1950s and 1960s. (Dementi Studio.)

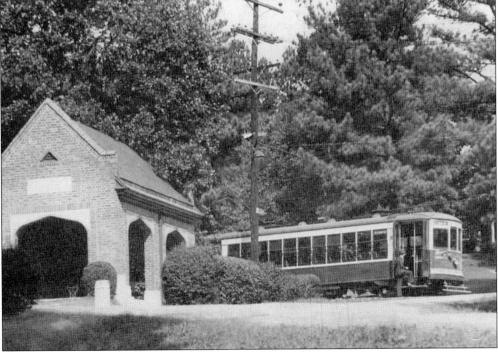

The streetcars were a familiar sight until 1947, when buses began to take their place. (Dementi Studio.)

According to the 1953 edition of the *Web*, Orchesis was a "modern dance organization . . . founded in 1949." Further, "eligibility for Junior Orchesis is based upon a girl's talent for dancing, her interest, and her poise during public performances." Members of the junior group were raised in status based on performance and approval of the senior group. Traditionally, Orchesis performed in the Greek Theater for the traditional Westhampton May Day festival. (Dementi Studio.)

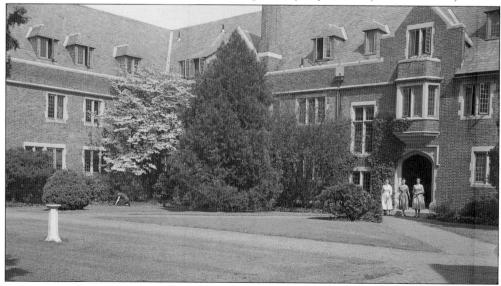

Dementi Studio served often as the official photographer for the yearbook, and the studio manages an impressive archive and visual record of the school to this day. This shot is typical of images taken by the studio, in a romantic style that seemed to fit the times, the image of Westhampton, and the picturesque qualities of the campus. (Dementi Studio.)

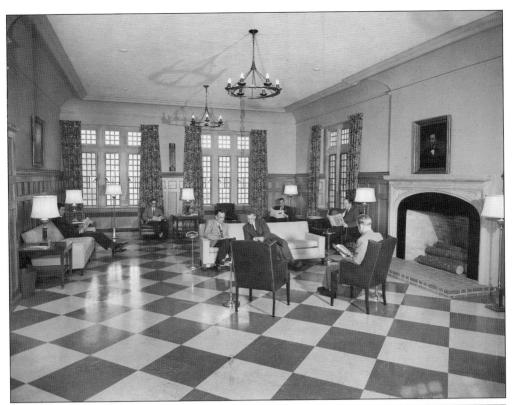

These two images, one of a lounge for Richmond men and a posed Dementi portrait of Westhampton women under the North Court arch, provide a glimpse of the separate spaces for men and women, along with the perceptions and ideals that accompanied those spaces. The apartments constructed in the 1980s would begin to change the clear separation, with male and female students eventually living on both sides of the lake. (Both, Dementi Studio.)

While it is a Southern university, snow on campus appears regularly in photographs from the *Web* during the 1950s and early 1960s. Skating on the lake also became a tradition during colder winters. (Dementi Studio.)

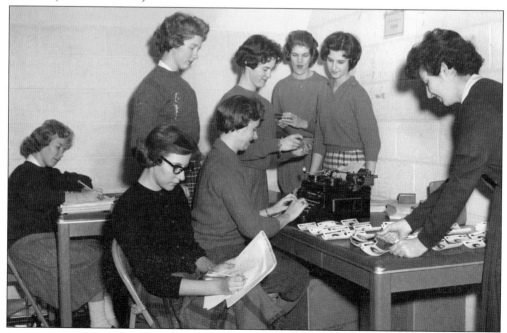

As seen with the *Web* yearbook staff pictured here, the school named separate editors and staffs for Westhampton and Richmond College. The coordinate system provided for the sharing of many campus facilities and faculty; however, Westhampton College and Richmond College were clearly separate entities with their own organizations and traditions. (Dementi Studio.)

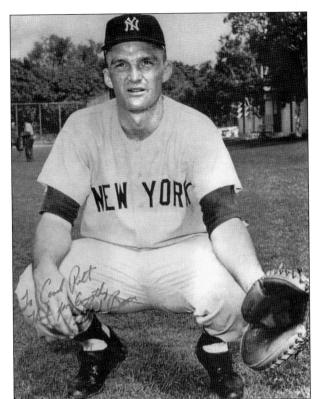

New York Yankee Chuck Boone signed this picture to Mac Pitt—his coach when Boone was a Spider on the 1960 team. Boone would return to his alma mater to serve as the athletic director. Malcolm Pitt was instrumental in the development of the athletic program at the University of Richmond. (Both, Virginia Baptist Historical Society.)

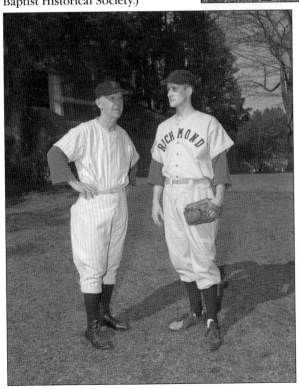

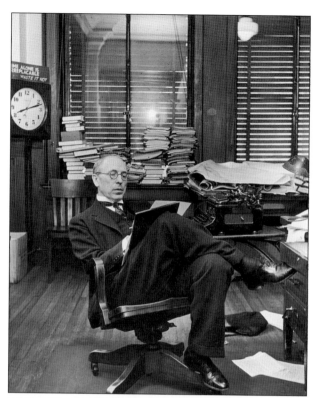

This photograph of Pulitzer Prize–winning author, editor of the *Richmond News Leader*, and Richmond College alumnus Douglas Southall Freeman was taken by famous *Life* photographer Alfred Eisenstaedt, who also took the iconic image of a sailor kissing a nurse in Times Square on V-J Day. Freeman won the Pulitzer for his multi-volume biographies of Robert E. Lee and George Washington. A proud member of the Richmond College class of 1904, Freeman served on the University of Richmond's board of trustees for 25 years, 16 of them as rector. Appearing on the cover of *Time* magazine in 1948, Freeman is one of the most well-known alumni, whose formative years on the Richmond College campus at Lombardy "laid the foundation of his intellectual life," according to his daughter. (Getty Images.)

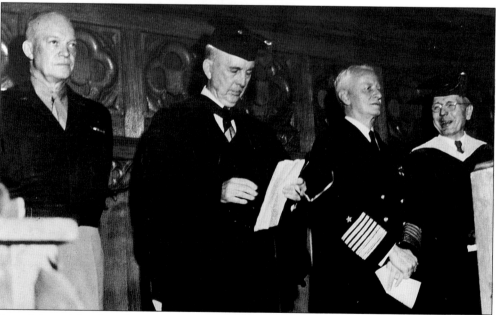

From left to right, Dwight Eisenhower, Pres. Frederic W. Boatwright, Adm. Chester W. Nimitz, and Douglas Freeman stand together for a tribute to the two war heroes. The University of Richmond played an important role during World War II with the U.S. Navy V-12 officer training program. Nimitz and Eisenhower were given honorary degrees from the board of trustees in 1946. (University of Richmond, communications department.)

Four

FIVE SCHOOLS, ONE UNIVERSITY
1969–2008

The story of the University of Richmond continues in 1969 with the generosity of a $50-million gift from a loyal Richmond College alumnus. E. Claiborne Robins, president of the A. H. Robins Company, provided the catalyst to transform the school from a local institution with a proud tradition of scholarship to a school with a vision for serving a more geographically diverse community well beyond the borders of the city and state. In the words of E. Claiborne Robins, upon the announcement of the gift, the school could aspire to be "one of the best small private colleges of its kind in the nation." E. Bruce Heilman became president in 1971 with the challenge and opportunities inherent with becoming the steward for the Robins gift. He succeeded in taking on this challenge, embracing progress while also building on the proud history of the University of Richmond.

Pivotal events in the University of Richmond's history appear to have redefined the school at every stage. These events include the early move from a seminary to a liberal arts college, the move from a college for men to a university with a coordinate system for men and women, and finally the move from a denominational institution with local enrollment to a nationally recognized university. With each turn of these events, the University of Richmond community has had the wisdom to embrace its history. The school celebrated its 175th anniversary in 2005, and it recently affirmed its commitment to the city with the opening of University of Richmond Downtown. Further, the school identifies itself currently as "Five Schools, One University," building on the "English plan" supported by President Boatwright for years.

Architect Ralph Cram's Collegiate Gothic architecture provides a symbol for the relationship of all alumni to the school, history, and the campus. Remaining constant, the stone buildings symbolize the enduring ideals of the University of Richmond. In contrast, as the years pass, fashions and trends are ephemeral and are only briefly captured by photographic images. The permanence of the buildings represents the concept that truth and ideals can be sustained, while each freshman class begins the process of seeing the University of Richmond through its own eyes.

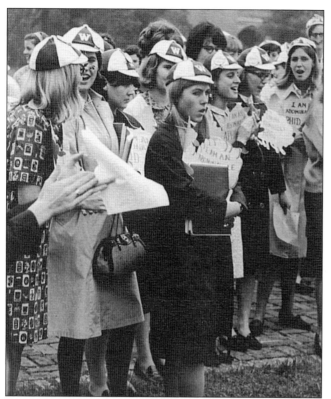

The rat tradition was still in place for these Westhampton women and Richmond men in the class of 1970. A long tradition at Westhampton and Richmond Colleges, a sampling of the rat regulations for Westhampton women during the 1917–1918 academic year identified prohibitions regarding specific aspects of campus life. The freshmen were told that "thou shalt not push nor crowd when boarding a street car . . . take possession of any boat except thine own, which floats upon Westhampton lake . . . pour the water and serve the butter . . . without murmur or complaint." (Both, *Web*.)

Westhampton women continued to eat in the North Court dining room until the opening of the E. Bruce Heilman Dining Hall in the 1980s. Prior to this, men would eat on the other side of the lake in Sarah Brunet Hall, which had been built as the original refectory in 1913. With the opening of the new Heilman dining facility, Brunet would be renovated to become the alumni center. (*Web.*)

University of Richmond alumnus Prof. Robert Alley came to the campus in 1968 with a doctorate from Princeton to teach in the religion department. Active in the American Association of University Professors, pushing to establish the tenure system, and defending academic freedom for the faculty, he was also an advocate for Westhampton and Richmond College students. (*Web.*)

In this picture, the *Messenger* staff appears to parody the popular fad of stuffing people in small places, such as telephone booths. Photographs in the *Web* over the years have provided a glimpse of fads, popular culture, and fashions on the University of Richmond campus. (*Web*.)

This photograph shows sports fans enjoying boxed fried chicken from Thalhimer's Department Store. Both Thalhimer's and Miller and Rhoads represented important traditions, as students continued to be connected to downtown department stores on Broad Street prior to the popularity of shopping malls appearing in the suburbs during the 1970s. (*Web.*)

Westhampton junior class officers are pictured taking part in a car wash fund-raiser. Car washes were a popular social activity, and advertisements for them were common, like the one in a 1965 *Collegian* announcing a car wash for the junior class to be held at the Phillips 66 across from the Village shopping center. (*Web.*)

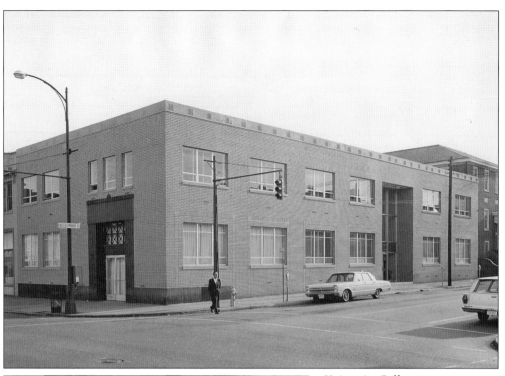

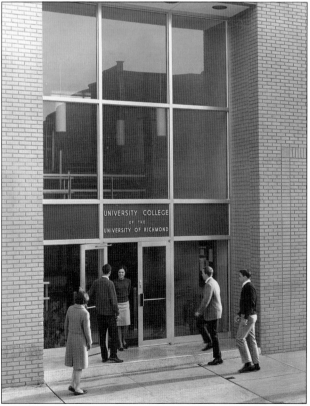

University College was established in 1962 as an alternative to the "day school" offerings. With its location at Lombardy Street occupying the Adams and Franklin Buildings, it served as a valuable connection to the Richmond business community. Students came to refer to the school as UCLA—University College on Lombardy Avenue. University College enrolled University of Richmond's first black student in 1964, followed by the admission of Barry Greene as a resident on the main campus in 1968. In its present form as one of the five schools of the University of Richmond, the School of Continuing Studies under the leadership of Dean James Narduzzi continues to provide a vital academic link to the Richmond community. (Both, Virginia Baptist Historical Society.)

Bobby Ukrop played for the Spiders from 1967 to 1969. He played as cocaptain in 1969. He would continue to have a close affiliation and various leadership roles with the school over the years, including serving as a member of the University of Richmond Board of Trustees. In this position, and with his visibility in the community as the president of Ukrop's stores, he was responsible for bridging ties with the city, the school, and its athletic program. Ukrop was inducted into the University of Richmond Hall of Fame during the 2004–2005 academic year. (University Athletics.)

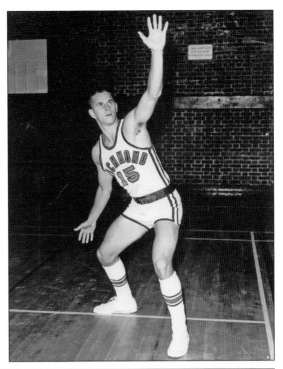

The Slop Shop added automat food machines in the 1960s, as seen behind these students sitting in a booth. The student center building, which is now part of Weinstein Hall, was the home for University of Richmond's post office and, for a period of time, a barbershop. (Virginia Baptist Historical Society.)

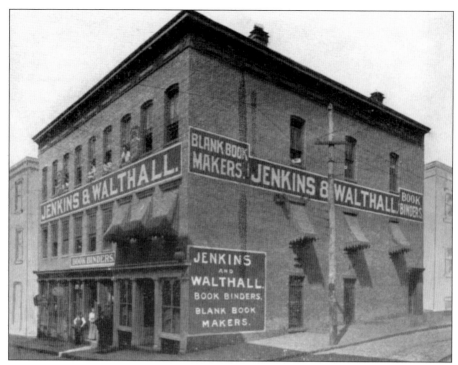

Professor of music Jim Erb is seen below posing with the chorus for a yearbook photograph in the Greek Theater, which continued to be a popular spot for music, special events, and theatrical performances in the 1960s. One of the many local businesses to support the school over the years was the bookbinding business of University of Richmond trustee Luther H. Jenkins. Jenkins provided the gift for the construction of the Greek Theater, which was dedicated in 1929, the same week as the Henry Mansfield Cannon Memorial Chapel dedication. As recent as the spring of that year (April 23), President Boatwright had sent a letter to Jenkins detailing the merits of building an "Outdoor Theatre" on campus. As a useful meeting place for the mild months of the year from spring to December and for such gatherings as the Shakespeare Festival, University Week, and the May Day celebration, Boatwright had architects give him plans that were inspired by outdoor theaters in Athens, Greece, which overlooked bodies of water. Boatwright planned for Richmond's Greek Theater to provide views of the lake through the woods. (Above, Library of Virginia; below, *Web*.)

Speak out, you got to speak out against
the madness, you got to speak your mind,
if you dare.
But don't try to get yourself elected.
If you do you had better cut your hair.

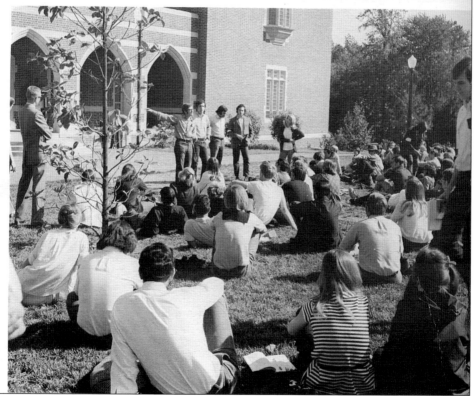

The protests in the 1960s and 1970s seen from students across the country were inspired by music and the events associated with the Vietnam War. These ideas found their way to the Richmond campus. The editors of the *Web* yearbook illustrated the spirit with this page layout of a campus student gathering, lyrics from Crosby, Stills, and Nash, and the demonstrative pose of popular drama professor Jack Welsh. E. Bruce Heilman served as president with principled leadership during the 1970s and 1980s. (*Web.*)

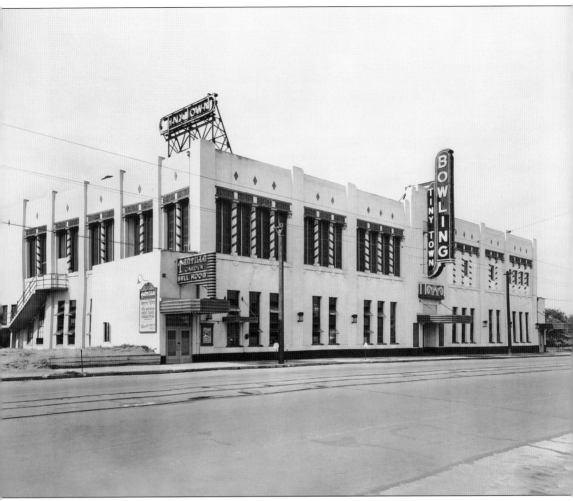

Tantilla Garden was a popular hangout and musical destination on Broad Street for students from 1933 to 1969. Advertisements for the establishment were featured regularly in the *Web* as "The South's Most Beautiful Ballroom." Offering "dancing nightly," the years of its operation saw major changes in music from orchestral to big bands, soul, and finally rock in the late 1960s. Over the years, colorful posters announced acts like Bob Tobias and his Orchestra, Spyder Turner and the Disciples of Soul, and a "graduation blast" in the spring of 1963 featuring Jokers Wild and the Escorts. (Library of Virginia.)

In 1971, Bruce Heilman was elected the fifth president of the University of Richmond. During his administration, many needed campus facilities were constructed, and existing ones were renovated. New programs were developed, and the student body became much more geographically diverse. In his first annual report as president in 1972, Heilman recognized the school's legacy as the foundation for a promising future. "We have been a fine school for many years because of the wisdom of those who have labored here through our history. Today, however, there is the feeling that we are all engaged in moving a good school to become a University of the first class." (University of Richmond, communications department.)

The School of Business was rededicated in 1979 and renamed the E. Claiborne Robins School of Business in recognition of Robins's generous gifts to the University of Richmond and his leadership in the business community as head of the A. H. Robins Company. The Robins family continued to provide gifts that would fund further building, which include Lora Robins Court, Lora Robins Gallery of Design from Nature, the Robins Center, and the E. Claiborne Robins Stadium to open in the fall of 2010. (Both, Virginia Baptist Historical Society.)

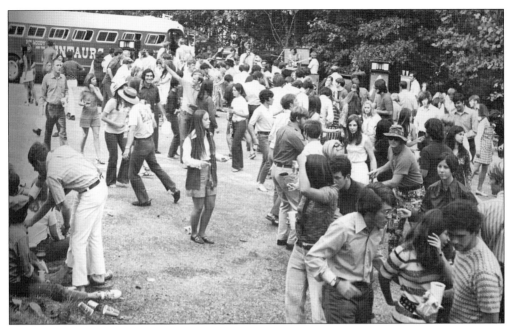

Outdoor rock concerts at the Greek Theater and at other locations on campus had a different feel in the context of the musical and cultural revolutions of the late 1960s and 1970s. Looking at the yearbooks in the 1970s, one can see the hairstyles change drastically with the new music. In 1977, the school's radio station went FM with a change from WCRC AM to WDCE FM 90.1 and a new studio in the Tyler Haynes Commons (WDCE staff are pictured below). Album rock rather than hit singles was popular in the late 1970s and early 1980s on WDCE, which prided itself in being an alternative to the top 40 of local Richmond stations. The album rock associated with FM could be heard beyond the campus in the West End of Richmond. (Both, *Web*.)

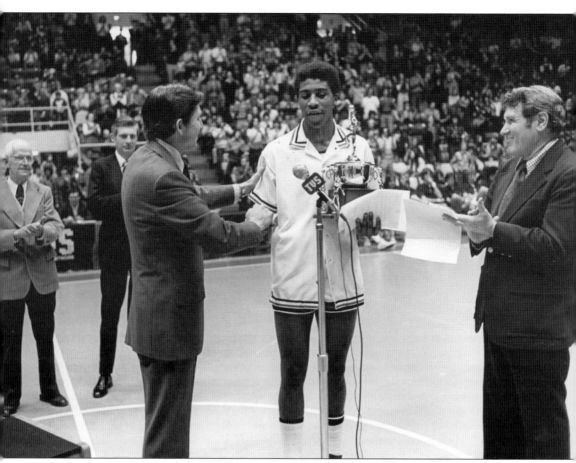

In the 1970s, Aron Stewart was a leading scorer for the Spiders as well as the first superstar to bring excitement to the new Robins Center. A pioneer African American athlete for University of Richmond, he was honored on Aron Stewart Day on February 23, 1974, and the *Collegian* reported that, "5,300 fans had turned out to honor the finest basketball player to ever don a Spider uniform." In this picture, Stewart is presented with a trophy from President Heilman and announcer Frank Soden, who broadcast basketball from 1950 to 1980 and football from 1969 to 1980. (Virginia Baptist Historical Society.)

The Westhampton Bridge, pictured here in 1947, had been a functional and symbolic aspect of the campus since the opening of the new campus. For years, it provided the means by which students moved from the Richmond College side to the Westhampton College side of the campus and symbolized the connection between the two schools. There was a gate at the bridge that was locked to enforce curfew regulations and rules for socializing between the men and women. The era of the bridge ended in 1975 when it was demolished to begin the construction for the Tyler Haynes Commons, which would be the new home for the Dry Dock, a student center, a bookstore, and the FM school radio station WDCE. A 1922 graduate of Richmond College, Tyler Haynes served on the University of Richmond Board of Trustees from 1963 to 1991 and served several terms as Chairman of the Student Affairs Committee of the Board of Trustees. As a student, Haynes was the business manager for the *Web* and was remembered in the senior pages as a reliable friend to his fellow students. (Right, Dementi Studio; below, Virginia Baptist Historical Society.)

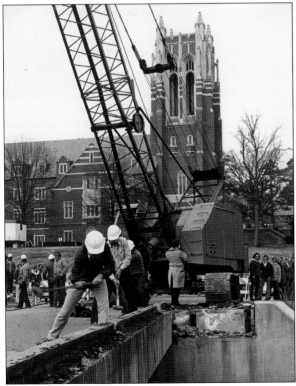

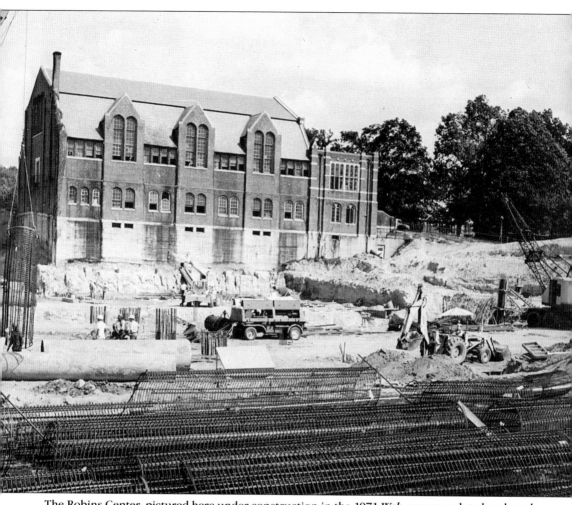

The Robins Center, pictured here under construction in the 1971 *Web*, was completed and ready for the official opening ceremonies on December 2, 1972. E. Claiborne Robins and his family received a warm welcome from the crowd as Robins threw out the ball for the first game played in the $10-million facility. The event also presented an opportunity for President Heilman and the University of Richmond community to thank the Robins family for the $50-million gift to the school in 1969. The Robins Center provided a long-awaited home on campus for basketball, which had been played in various facilities around town, including in the 1960s the Richmond Arena near Parker Field, which would become the home of the Richmond Braves baseball team. In the early 1970s, the Robins Center also played host to the rock music of the day, featuring Humble Pie and Spooky Tooth in 1974. Early performances also included the Nitty Gritty Dirt Band. The new Robins Center was the site of a challenge to set a Guinness World Record by consuming the largest submarine sandwich. One continuous sub was prepared on a table that ran the full circumference of the Robins Center. Hundreds of students and the local community attended the event. As the *Collegian* reported in its headline, the goal was to "sink the largest sub." (*Web*.)

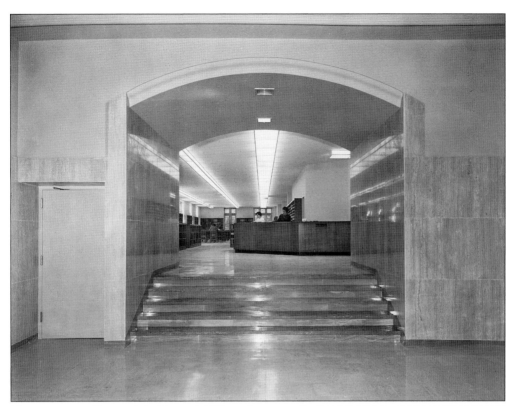

This is a view of Boatwright Memorial Library's original main entrance, which has been adapted for offices and the Media Resource Center. The exterior entrance is now limited to library employees, and the main entrance now faces the lake. It is fitting that the new library was named in memory of President Boatwright's contributions to the University of Richmond. Boatwright championed the cause of a larger library endowment and more space for the library from the days the books were collected in Jeter Memorial Hall by Charles Ryland on the downtown campus. Furthermore, Boatwright stated that "the library is the most vital building in a university. It is the universal laboratory where every student and every teacher does his work . . . especially as the library becomes more important in the last half century as the emphasis in college has shifted from teaching to learning. The quality of education provided by a college is directly dependent upon the library, and the educational value of an institution will rise or fall as its library is strong or weak." The card catalog drawers would vanish from Boatwright Memorial Library with the introduction of digital catalogs and databases. (Above, Virginia Baptist Historical Society; right, *Web*.)

Raymond E. Pinchbeck held a doctorate in economics and came to the University of Richmond in 1929 to become a professor in applied economics. He served as dean of Richmond College students beginning in 1933. His tenure was interrupted by World War II, with his service in the U.S. Navy from 1942 to 1945. A *Collegian* obituary for Pinchbeck in 1957 described the professor as having "a unique combination of gentlemanliness, scholarship, civic mindedness, Christianity, administrative efficiency, [and] humor." Writer and Hollywood producer Earl Hamner, who attended the University of Richmond from 1940 until being drafted in 1943, shared the high regards many students held for Dean Pinchbeck. He showed this respect by creating the character Dean Beck to represent Pinchbeck for several episodes of *The Waltons* in 1975, when "John-Boy" as Hamner attends the fictional Boatwright University. While at the University of Richmond, Hamner had lived in the home of three aunts not far from campus. He pursued his first serious study of writing with English professor Lewis F. Ball. As a successful writer, Hamner continued to return to his alma mater, and he received an honorary degree from University of Richmond in 1974. (Above, *Web*; below, Getty Images.)

Physics professor Charles Albright is pictured working with an unidentified student in a Richmond Hall lab. Richmond Hall, which served as the school's physics laboratory, was dedicated in 1930 with a ceremony and speech by Karl Taylor Compton, president of M.I.T. Prior to the construction of the Gottwald Science Center (below), the science complex also included Puryear Hall for chemistry and Maryland Hall for biology. (Above, Dementi Studio; below, Virginia Baptist Historical Society.)

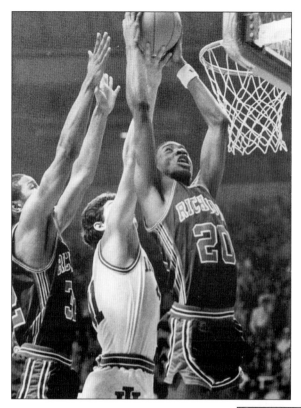

Becoming the basketball head coach in 1981, Dick Tarrant (below) ended his career in 1993 at University of Richmond with a career record of 239-126. He coached the Richmond Spiders to eight winning seasons. The team and Tarrant received national recognition with an upset win over Syracuse in 1991. His star player in the 1980s, Johnny Newman, is the school's all-time leading scorer with 2,383 points. After graduating in 1984, Newman went on to play professionally with the Milwaukee Bucks, the Denver Nuggets, and the Cleveland Cavaliers. (Left, University Athletics; below, Virginia Baptist Historical Society.)

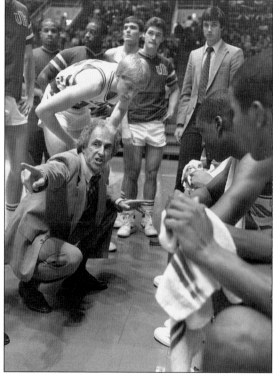

Gerald Ford made a campaign stop for presidential candidate Ronald Reagan and Thomas Bliley for Congress on October 16, 1980. Arriving by helicopter, Ford landed on Pitt Field and spoke during a brief appearance at the Greek Theater. (University Facilities.)

Defining and initiating perestroika in the Soviet Union during the 1980s, reform leader Mikhail Gorbachev toured Virginia and spoke at University of Richmond's Robins Center in the spring of 1993. President Morrill hosted many international speakers visiting the campus in the early 1990s. Invited by the new Jepson School of Leadership Studies, as reported by the *Richmond Times Dispatch* on April 13, 1993, Gorbachev espoused the idea that while leaders are born and not made, schools like Jepson can "prepare and groom those with the talent and ability, just as diamonds form naturally but are cut and polished." (Doug Buerlein Photography.)

Buildings clearly not consistent with the Collegiate Gothic style of architecture of the original campus, the modular units above went the way of the temporary barracks, returning the space to a parking lot across from the original stadium. For a brief shining moment in the 1980s, they provided students with the best temporary prefab housing available. (University Facilities.)

In the 1980s, American youth were given MTV, and the styles of punk and new wave affected the fashion of Richmond and Westhampton students as well. This humorous take in the 1984 *Web* ran with the headline, "From Prep to Punk," referring to punk music and preppy styles, which were parodied in a popular book at the time, *The Preppy Handbook*. The changes in popular culture were seen on campus and were recorded in the images of the school yearbook. (*Web*.)

The University of Richmond received national recognition in 1992 in a *New York Times* article, "Made, Not Born." It stated that University of Richmond was "the first liberal arts institution to offer a bachelor's degree in leadership studies," and as a result, it "has leapfrogged to the head of the leadership pack by virtue of the $20 million Jepson School of Leadership Studies, the gift of Robert S. Jepson Jr., a businessman and Richmond alumnus, and his wife, Alice." In that same article, President Morrill discusses the mission of the school to create leaders. "We only desire an intensification of what we already see as the stock-in-trade of a liberal education—the unity of knowing and doing." Gen. Norman Schwarzkopf gave the keynote speech during a ceremony that featured the dramatic aerial entry of the members of the ROTC, pictured here. (Both, Doug Buerlein Photography.)

Two *New York Times* headlines on March 15 and 16, 1991, told the story of the Spiders upset over Syracuse in the NCAA tournament: first, "Spiders Set Tempo and Syracuse Fell Flat," and then, "Orangemen Stunned, 73-69, by Richmond; Richmond Stuns Syracuse." Leading the team to victory, coach Dick Tarrant described their strategy in the *New York Times* March 16 article. "Our whole game plan was to get the lead early and pick up the 12,000 neutral people who were going to be with David against Goliath." The Spiders ended their run in the Sweet 16 with a defeat to Temple University. (University Athletics.)

Carrying on a long tradition that began with coach Fanny G. Crenshaw introducing field hockey in 1914, the Westhampton team won five consecutive Atlantic 10 tournament titles from 2001 to 2005. (*Web.*)

Tom Wolfe was the University of Richmond commencement speaker in 1993. A native of Richmond, Wolfe retains close ties to Virginia as a graduate of Washington and Lee University and St. Christopher's School. Before receiving national attention as a "new journalist," Wolfe received a doctorate in American studies from Yale University. Pres. Edward L. Ayers recognizes Wolfe as an influence in his decision to pursue and receive the same degree at Yale. Wolfe spoke on the topic of architecture at University of Richmond following the publication of his book *From Bauhaus to Your House* in 1984. His novel *I Am Charlotte Simmons*, published in 2004, involved extensive research by Wolfe, who visited American college campuses. There are no reports that Wolfe visited the University of Richmond campus specifically for this research. (Doug Buerlein Photography.)

James MacGregor Burns won a Pulitzer Prize for his biography on Franklin Roosevelt (*Roosevelt: Soldier of Freedom 1940–1945*, published in 1971). Burns's 1978 book on leadership described the need for the study of leadership in education. He served as a senior scholar of the Jepson School of Leadership Studies from the opening of the school in 1991 until 1993. (Virginia Baptist Historical Society.)

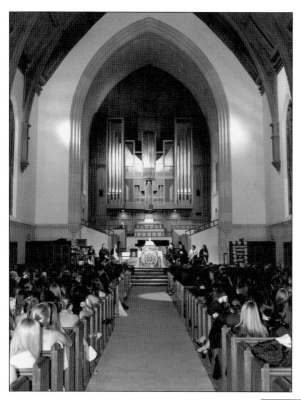

A defining Westhampton tradition, Proclamation Night is an annual event during which students write a letter to themselves as first-year students to be opened and read their senior year. It has been an event on the Westhampton campus since the opening of the school in 1914. It is one of the traditions that has defined the close community and special experience of the Westhampton graduate. (University of Richmond, communications department.)

In recent years, the University of Richmond has committed to taking a lead with Habitat for Humanity and other community service projects. The school's chaplain from 1974 to 1996, Dr. David Burhans supported the efforts, as he and the Reverend David F. H. Dorsey reported on the range of activities in the spring 1997 issue of *University of Richmond Magazine*, stating that "Richmond students have raised more money for Habitat than any other college or university in the country." (University of Richmond, communications department.)

The image above shows the construction of the Gumenick Academic and Administrative Quadrangle, which connected Puryear, Maryland, and Richmond Halls. Construction sites were common on campus in the 1990s. Along with the construction of Jepson Hall, pictured below, the school received a generous gift from the Weinstein family—alumnus Marcus Weinstein; his wife, Carole M. Weinstein; their daughter, Allison Weinstein, and son-in-law Ivan Jecklin—to build Weinstein Hall, which would become home for the social sciences. Further, Weinstein donations made possible the building of the popular Weinstein Center for Recreation and Wellness attached to the Robins Center and the Carole Weinstein International Center, to be completed in the fall of 2010.(Both, Virginia Baptist Historical Society.)

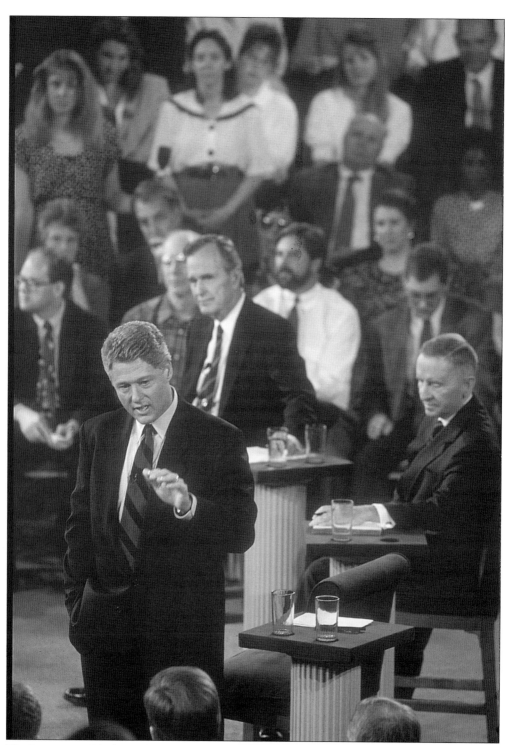

The University of Richmond campus was the site of one of the 1992 presidential debates. News pundits declared Bill Clinton the winner of this debate, speculating that George Bush may have lost support and the election by appearing detached and looking at his watch. (Getty Images.)

Dan Roberts, associate professor of history and chair of the School of Continuing Studies Liberal Arts Program, has given a voice to University of Richmond with historical vignettes entitled "A Moment in Time," which are featured on public radio WCVE. He signs off with, "at the University of Richmond, this is Dan Roberts." (Doug Buerlein Photography.)

Along with the television series *Dawson's Creek*, the University of Richmond campus has been featured as a location for several Hollywood productions. In the horror film *Cry Wolf*, the campus buildings are depicted as a prep school. The campus is clearly identifiable, and the architecture and grounds are photographed beautifully. In the 2005 television series *Commander in Chief*, actress Geena Davis plays the first woman U.S. president. The school is identified by name: Davis's character had served as chancellor of the University of Richmond before being selected as vice president of the United States. (University of Richmond, communications department.)

Joe Nettles was well respected by faculty and students, as can be seen by this affectionate caricature that appeared in the *Web* alluding to his impressive work ethic. He was alumni secretary from 1936 to 1970 and public relations director for the University of Richmond for the same years, and he served as an instructor of journalism from 1940 to 1973 and as the director of the nascent journalism program from 1970 to 1973. Nettles was remembered fondly by two successful journalists—Guy Friddell, a columnist at the *Norfolk Virginian Pilot* and *Ledger Star*, and Paul Duke, who worked for the Associated Press, the *Wall Street Journal*, and NBC News and was the host of PBS's *Washington Week in Review* from 1974 to 1994. Duke's relationship with Nettles is reported in the following excerpt of a July 19, 2005, *Washington Post* article. "He took a basic journalism course his senior year simply because he needed the credit. Taught by a legendary professor named Joe Nettles, it hooked him. After Mr. Duke graduated in 1947, Nettles helped him get a job covering sports for the Associated Press in Richmond. He was a 21-year-old rookie." (*Web*.)

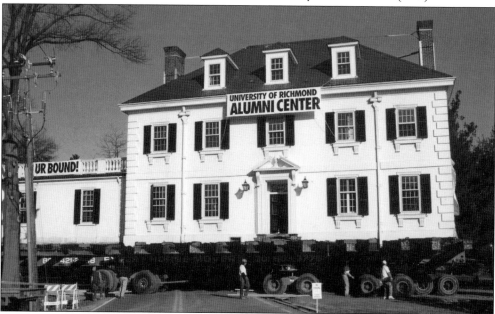

A new home for University of Richmond alumni was delivered on a flatbed on March 24, 1996. Alice and Bill Goodwin Jr. donated their house, designed by William Lawrence Bottomley, a renowned architect with numerous houses on the National Register of Historic Places, including several on Monument Avenue. The Bottomley House became the core of the new Jepson Alumni Center. (University of Richmond, communications department.)

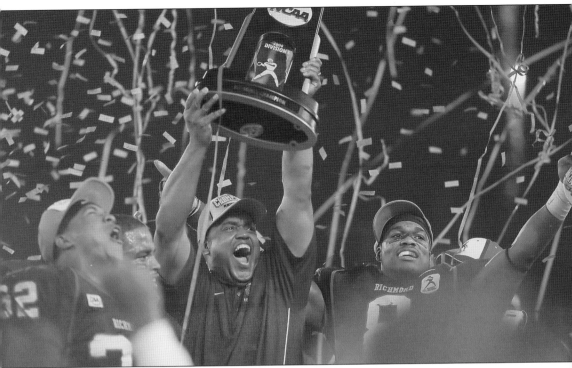

Proud students and alumni watched as the Spiders football team triumphed over Montana 24-7 in the finals to become the 2008 NCAA Division I FCS champions, led by coach Mike London, a loyal University of Richmond alumnus pictured here celebrating with his team. The championship team would play its last season in the University of Richmond Stadium in 2009, coming home for the fall season of 2010 to play in the new E. Claiborne Robins Stadium on campus. (University Athletics.)

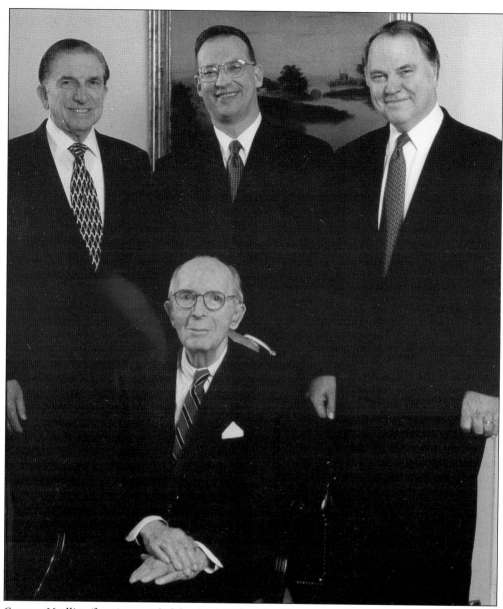

George Modlin (front) provided leadership for significant growth in campus programs and buildings. Heilman (left) like Boatwright in an earlier time provided leadership at a defining moment in the school's history. Samuel Banks (not pictured) followed Heilman as university president, with a tenure cut short by health issues. Richard Morrill (right) took the reigns with steady leadership and an eye toward growth as he supported the opening of the Modlin Center for the Arts and the Jepson School of Leadership Studies. Morrill's view of the school as a national university was solidified by securing the 1992 U.S. presidential debate. Further growth came under William Cooper (middle) and his administration as he launched the Richmond Quest Program, initiated a major fund-raising campaign, and proudly publicized the school's recognition as a top school by *U.S. News and World Report*. (University of Richmond, communications department.)

University of Richmond Downtown opened as a collaborative venture between the Bonner Center for Civic Engagement and the University of Richmond School of Law. It renewed the school's connection to the city that began in 1834 with Richmond College's move to Haxall's Columbia house. The Evening School of Business Administration and University College continued this tradition in the 20th century after the move to the western campus in 1914. (University of Richmond, communications department.)

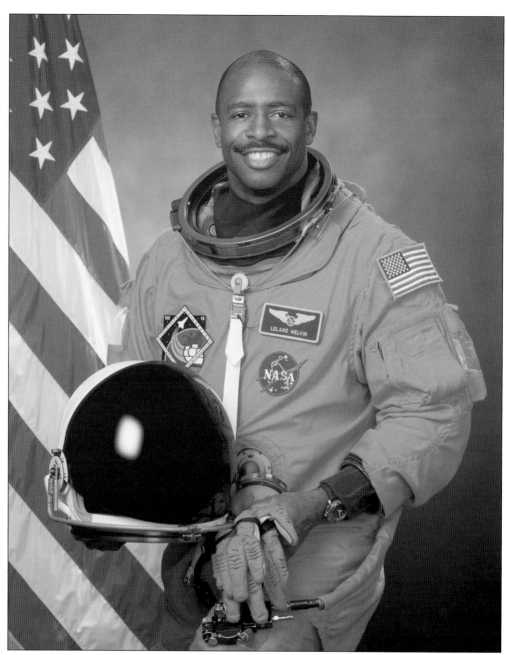

Graduating in 1986, Leland Melvin had excelled in the chemistry lab and on the football field. After college, he pursued a career as a scientist with NASA's Langley Research Center and was involved in the teacher-in-space program during the difficult period after the *Columbia* disaster. At that time, he was mentioned in a *New York Times* article as being inspired and impressed by the fact that the disaster "had not dimmed the enthusiasm of school children." As an astronaut, he became an active member of the *Discovery* shuttle program. He would become the University of Richmond's first Spider in space. (NASA.)

Dr. Edward L. Ayers became the University of Richmond's ninth president in the fall of 2007. In Ayers's inauguration speech on April 11, 2008, he provided a vision for the future in the context of the University of Richmond's past and the commitment of faculty, staff, and students to the university and progress. "If we go back to the frame building occupied by the struggling Baptists of 1830, we see a common purpose that stretches across 10 generations to ourselves. If we look at the edges of the story, into the shadows, we see things we cannot see in the broad light of the middle. If we listen carefully, we can hear quieter stories that tell us something important about the enduring spirit of this place." (Jan Hatchette.)

www.arcadiapublishing.com

MAP SEARCH

Discover books about the town where you grew up, the cities where your friends and families live, the town where your parents met, or even that retirement spot you've been dreaming about. Our Web site provides history lovers with exclusive deals, advanced notification about new titles, e-mail alerts of author events, and much more.

Arcadia Publishing, the leading local history publisher in the United States, is committed to making history accessible and meaningful through publishing books that celebrate and preserve the heritage of America's people and places. Consistent with our mission to preserve history on a local level, this book was printed in South Carolina on American-made paper and manufactured entirely in the United States.

This book carries the accredited Forest Stewardship Council (FSC) label and is printed on 100 percent FSC-certified paper. Products carrying the FSC label are independently certified to assure consumers that they come from forests that are managed to meet the social, economic, and ecological needs of present and future generations.

Find *Your* Place in History.